THEN *&* NOW

MONTGOMERY COUNTY

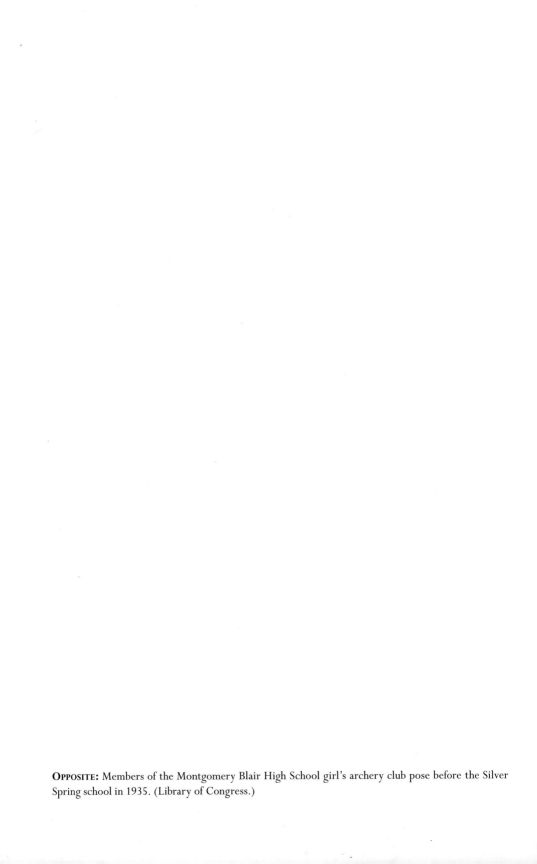

OPPOSITE: Members of the Montgomery Blair High School girl's archery club pose before the Silver Spring school in 1935. (Library of Congress.)

THEN & NOW

MONTGOMERY COUNTY

Mark Walston

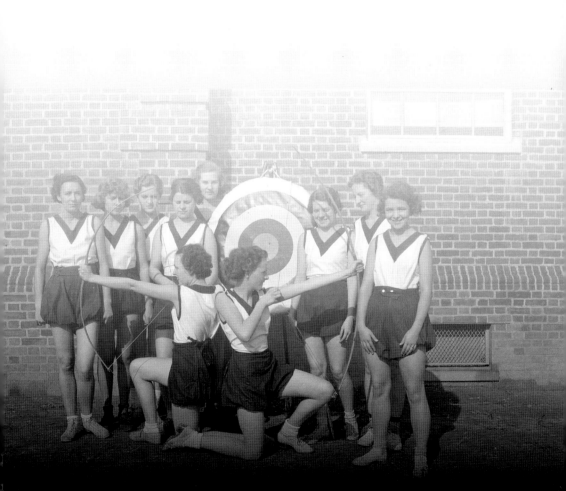

Copyright © 2011 by Mark Walston
ISBN 978-0-7385-8757-8

Library of Congress Control Number: 2011920041

Published by Arcadia Publishing
Charleston, South Carolina

Printed in the United States of America

For all general information, please contact Arcadia Publishing:
Telephone 843-853-2070
Fax 843-853-0044
E-mail sales@arcadiapublishing.com
For customer service and orders:
Toll-Free 1-888-313-2665

Visit us on the Internet at www.arcadiapublishing.com

ON THE FRONT COVER: In 1903, the ownership of the Glen Echo amusement park property was transferred to the Washington Railway and Electric Company, which operated the trolley running from Washington, DC, to the park entrance gate. The stone turret at the park's entrance, built in 1891, was a holdover from its earlier incarnation as a Chautauqua educational center. Admission to the park was free; profits came from trolley fares as well as the park's rides, games, and concessions. (Library of Congress.)

ON THE BACK COVER: Revelers enjoy the opening of the new swimming pool at Columbia Country Club in Chevy Chase in 1925. (Library of Congress.)

CONTENTS

Acknowledgments

Over the years, I have worked in a variety of positions in the field of history at local, state, and national levels, for organizations public and private. I have been a historic sites researcher and trail guide author for Sugarloaf Regional Trails; a curator for the Montgomery County (MD) Historical Society; a miller in a restored 19th-century gristmill for the Fairfax County (VA) Park Authority; a park historian for the Maryland–National Capital Park and Planning Commission; a writer and editor for the Maryland Historical Trust; and a historian for the US Department of the Treasury, US Customs Service—the first historian ever hired by the service. I have written numerous books, essays, and articles on a wide range of historical topics, from 18th-century American slave culture, to 19th-century Civil War poetry, to 20th-century shopping centers. Along the way, I met innumerable people who shaped my perception of the pivotal role history plays in understanding who we are as a people, not only where we have come from, but why we are the way we are today—and by extension, what we might be tomorrow. I have come to realize the importance of maintaining the tangible pieces of our past for the enlightenment of the present, whether it is through the preservation of historic buildings, landscapes, and streetscapes in our communities, the display of objects both common and extraordinary in museums and galleries, or the conservation of archival materials for the edification of future generations. Of the latter, this nation is blessed with an incomparable institution—the Library of Congress. The historic photographs in this book were culled from the millions of images within the library's holdings. In taking the accompanying modern photographs, I tried to position myself as close as possible to the stance of the original photographer. The difference in the focal plane of cameras of yesteryear and today—and physical obstacles onsite—made exact duplication in some cases impossible. But still the progression of time is evident. And with few exceptions, the sites explored in this book are readily visible to the public, either as visitation sites or on parkland or along county roadways, so that interested viewers might use this book as a guide on their own journey into Montgomery County's history.

Introduction

In 1608, Capt. John Smith, founder of the original Jamestown settlement in Virginia, journeyed far up the Potomac River, exploring unchartered waters. He reached a point above present Washington, DC, and, in the peculiar spelling of early English, recorded his observations:

> The river . . . maketh his passage downe a low pleasant valley overshadowed in manie places with high rocky mountain from whence distill innumerable sweet and pleasant springs . . . Having gone so high as we could with the bote, we met divers savages in canowes well loaden with flesh of beares, deere, and other beasts whereof we had part. Here we found mighty rocks growing in some places above the ground as high as the shrubby tree.

Thus, John Smith and his band became the first Europeans to visit what would eventually become Montgomery County. Yet, the first visitors arrived more than 10,000 years before Smith. Eons earlier, Native American tribes had crossed the Alleghenies, eventually settling in the Potomac River valley. Here, over millennia, they traversed the ancient forests in search of game, which was in abundance. They fished the waters. They gathered wild fruits and nuts. Eventually, small agricultural villages appeared, with tribes settling in simple dwellings built beside fields of corn and beans. These were the "savages" encountered by Smith and his men on their first foray into the county.

The trails worn through the forests by the Native Americans would become the paths followed by European pioneers in the 17th century, who came to the area to trade with the natives and hunt bears, beavers, and other animals whose fur found a ready market in the Old World. Eventually they drove the natives from the land, opening the way for settlers, who by the end of the 17th century had begun to clear the forests to cultivate a plant, shared by the natives, that became the basis of the county's economy—tobacco. The settlers built rude farmsteads out of log and rough-hewn timber. And they brought African slaves to work the land.

Tobacco was the prevailing cash crop and would dominate Montgomery agricultural pursuits well into the 18th century. It would give rise to the county's major port, Georgetown, where local farmers would market the products of their fields. (The county would eventually lose its port town in 1791, when it was incorporated as part of the newly established District of Columbia.) Tobacco made many in the county rich enough to abandon simple log structures in favor of more substantial brick, stone, and wood-framed houses, their refined features symbols of Montgomery's growing maturity.

By 1776, the area's population had grown large enough to warrant the creation of a new political jurisdiction, and Montgomery County was formed, bounded by the Potomac River to the west and the Patuxent River to the east. It was named for Revolutionary War hero Gen. Richard Montgomery, who fell at the Battle of Quebec.

By the end of the 18th century, tobacco's fortunes had waned. In its stead rose wheat, which engendered a plethora of mills throughout the county, grinding grain and transforming it into flour, which was then exported overseas to a hungry European market The county's location along the fall line, where the rocky Piedmont breaks into the Coastal Plain, created innumerable fast-moving streams, which turned the waterwheels of commerce.

To facilitate the movement of goods, turnpikes were established—today's Rockville Pike and Georgia Avenue among them—creating a network of broad thoroughfares wide enough to accommodate loaded wagons headed for the Washington market. More significantly, the Chesapeake and Ohio Canal was created, begun in 1828 and by its completion in 1850 stretching 185 miles from Washington, DC, to Cumberland, Maryland, affording farmers along the way a new means of carrying products to market.

Agriculture was the mainstay of the county's economy throughout the 19th century, and the county's brightest minds were dedicated to its improvement, experimenting with new fertilizers to replenish worn fields and developing new machinery to boost efficiencies. Notably, Thomas Moore, a Brookeville-area engineer, would patent in 1810 a unique device to help dairy farmers keep their products cool when transporting them to market. He coined a new term for his invention—the refrigerator. Yet, it would be the arrival of the Baltimore and Ohio Railroad in 1873 that provided the greatest impetus to the expansion of county agriculture. Now, farmers had a quick and reliable means of transporting their goods to Baltimore, Washington, and beyond. All along the line towns grew around station stops, from Takoma Park through Rockville to Gaithersburg and beyond, up to Dickerson at the county's northern border. Older villages bypassed by the railroad languished.

The coming of the electric trolley in the late 19th century would have a profound, transformative effect on the county's progress. Trolley tracks fanned out from the center of Washington, DC, eventually crossing the border into Montgomery County and giving rise to new suburban developments such as Chevy Chase, Kensington, Glen Echo, and more, each vying to attract residents with the promise of a stylish new home in a sylvan setting, surrounded by fresh air and clean water and all within an easy, trolley car commute to the burgeoning government jobs sprouting all around the nation's capital.

That suburban movement would gain momentum in the early 1900s with the explosive growth of the automobile culture. Now, development was freed to proceed where it pleased, no longer confined to trolley and railroad tracks to shuttle people in, out, and around the area. Soon, the number of people living in auto-oriented communities down-county would eclipse the population of the older up-county farm villages, their residents still tied to traditional agricultural pursuits.

Even the Great Depression beginning in 1929 could not dampen the quickening pace of the county's growth; in fact, the number of government paychecks filling the coffers of area banks made the down-county area somewhat resistant to the brutal economic conditions being suffered by other communities in the area. Commercial corridors appeared along the main roadways leading from Washington—Georgia, Connecticut, and Wisconsin Avenues—filled increasingly by the 1930s with stores and offices to serve the needs of the new suburbanites. Bethesda and Silver Spring became major business centers and, in the years between World Wars I and II, would see the construction of the first of what would become a ubiquitous feature of the suburban landscape, the shopping center, beginning with simple strips of connected shops and culminating in the 1950s with the appearance of Wheaton Plaza, at the time of its opening the fourth largest shopping mall in the United States.

The tremendous growth of the federal government during World War II would push the county's population past the half-million mark and accelerate the spread of suburbia. By the 1960s, business boomed in Montgomery, with high-rise company headquarters ringing the newly constructed Beltway and lining Interstate 270, transforming the county from simply a bedroom community for Washington to a major employment center. Now, with nearly a million residents, the county is ranked among the 50 most populous counties in the nation and in the top 10 of the wealthiest—a world away from its humble agricultural beginnings.

HOME AGAIN

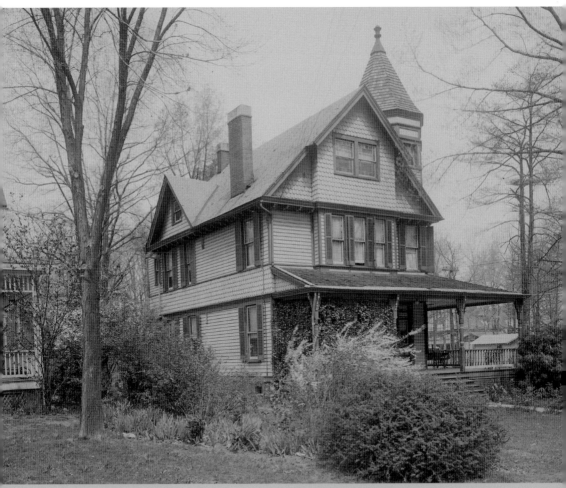

In 1883, B.F. Gilbert purchased 100 acres of land in Washington, DC, and Maryland with the goal of creating a "sylvan suburb of the National Capital." One of the first railroad-accessible developments, the community, named Takoma Park, soon grew to over 1,000 acres and became home to countless Washington workers who commuted from their stylish houses in the suburbs, like this one on Main Street, to government jobs downtown.

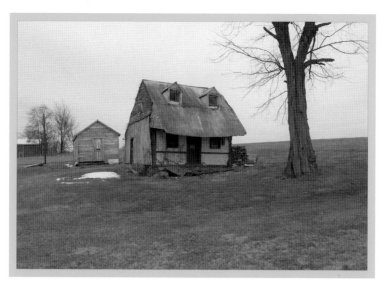

English settlers began arriving in the upper sections of the county in the early 18th century, and this small, unassuming log house near Damascus was typical of the early dwellings built on what was then Montgomery's frontier. In time, the rude log cabins would give way to more substantial frame, brick, and stone houses as the county's agricultural industry matured—in particular, the cultivation of tobacco, the county's early cash crop.

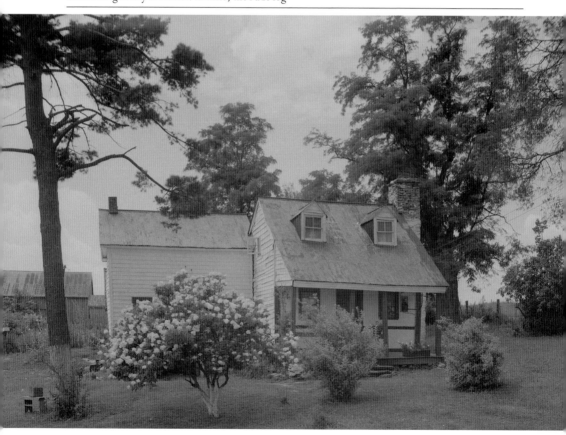

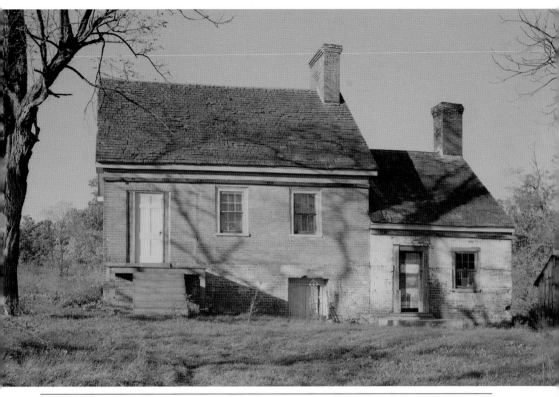

This simple, one-and-a-half story brick dwelling was built in the 1790s by Peter Kemp as the miller's house for the nearby sawmill and gristmill he operated along Paint Branch. Despite a later wood frame addition in the mid-20th century, many of the house's original features remain, including the unique double fireplace in the main first-floor room and the large, open kitchen fireplace in the cellar. Today, it sits within Valley Mill Park.

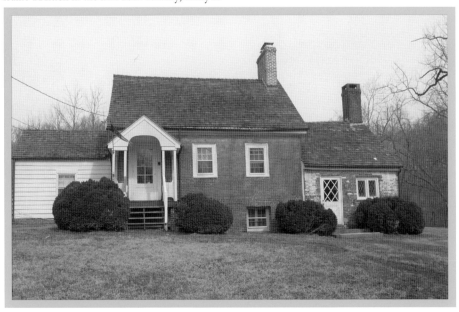

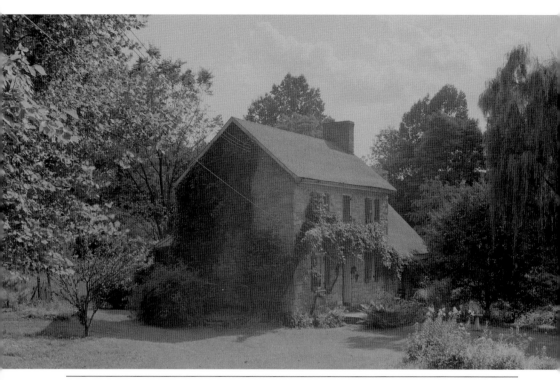

One of the remaining late-18th century buildings in the town of Brookeville, Valley House, with its simple symmetrical form laid up in local stone, is a handsome example of the Georgian-style home popular during the period. A milling enterprise was associated with the property during the 19th century.

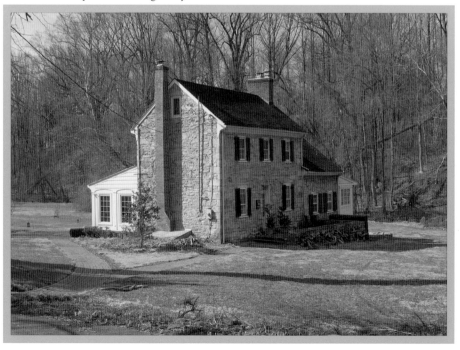

Commerce blossomed early at the wagon crossroad that is today Olney—originally named Mechanicsville for its collection of blacksmith and wheelwright shops. One of the earliest dwellings in the area was Fair Hill, built in the 18th century by the Brooke family. The house later served as a Quaker school. The dwelling was demolished in the 1970s to make way for a modern shopping center.

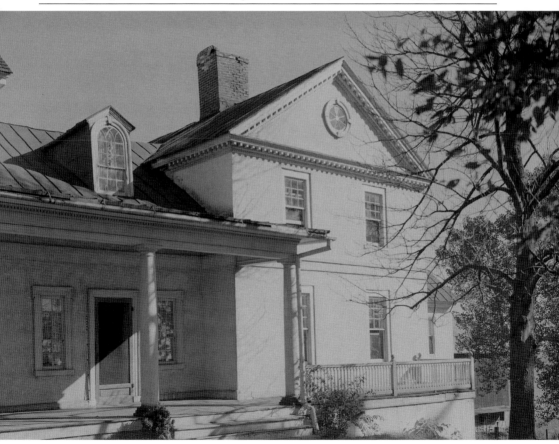

Known as "Woodlands," the main section of this house was built in 1812 by Francis Cassett Clopper, a wealthy landowner who gave his name to the current Clopper Road, running from Gaithersburg out to Germantown. Clopper also operated a gristmill on the property, as well as a woolen mill, which manufactured blankets. The homesite today lies within Seneca State Park.

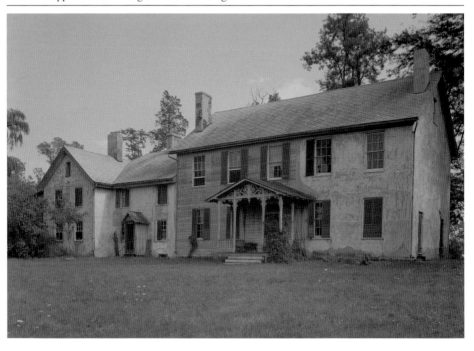

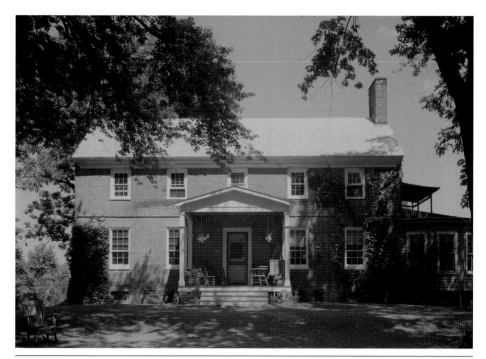

James Brooke, whose original land holdings dated back to a 1745 patent with Charles, Lord Properietor of Maryland, acquired more than 20,000 acres of land in the Sandy Spring-Olney area. Huge portions of the land remained in the Brooke family for generations. This simple brick dwelling was built by Gerard Brooke sometime in the 1810s, presumably for his son Richard. The house now sits among the playing fields of the Olney Boys and Girls Club.

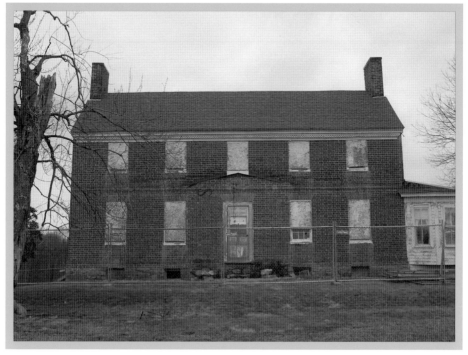

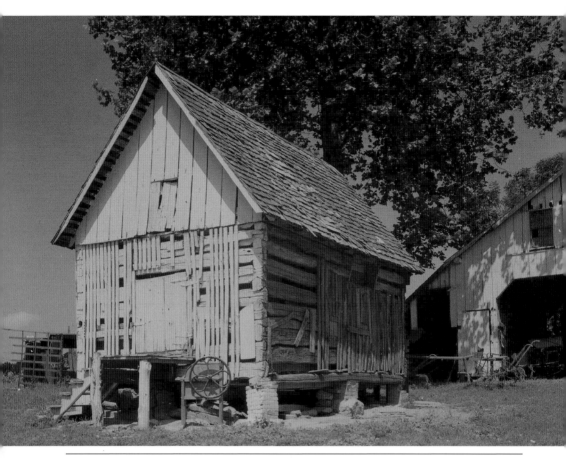

Corncribs, such as this one on the early 19th-century Falling Green estate near Olney, were typical sites on area farms through the 20th century. After the harvest, corn would be placed in the crib for drying, with the openings in the walls allowing air to circulate through the corn. The openings exposed the corn to pests, so most cribs were elevated above the ground, presumably beyond the reach of rodents.

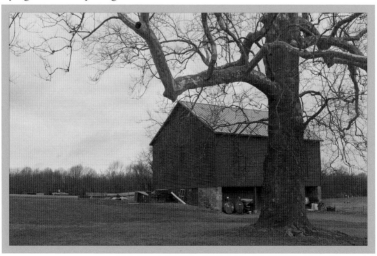

Springhouses, usually small, only one room, and constructed over the source of a spring, used naturally cool waters for the refrigeration of foods that would otherwise spoil in the spring and summer months, such as meats, fruits, and dairy products. This stone springhouse stood on the Olney House property, near the intersection of Georgia Avenue and the Olney-Sandy Spring Road. The historic house, begun in the early 1800s, still stands nearby and operates as a restaurant.

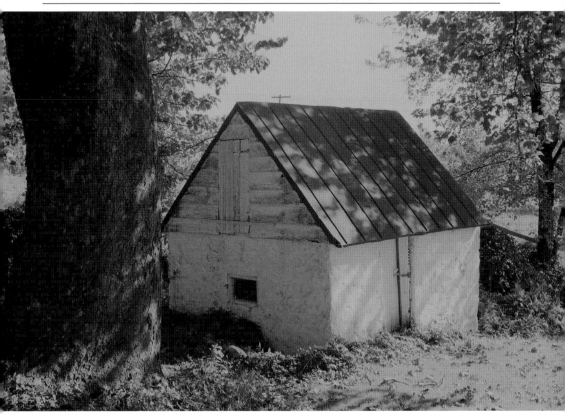

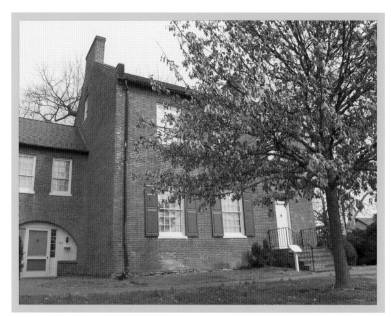

Built in 1815, "Beallmont"—also known as the Beall-Dawson House—is an elegant reminder of the early history of the county seat, Rockville. The grand home, designed in the Federal style, was constructed by Upton Beall, second clerk of the Montgomery County court. Today, the property is owned by the City of Rockville and has been restored to an earlier appearance by the Montgomery County Historical Society, which operates the building as a furnished house museum.

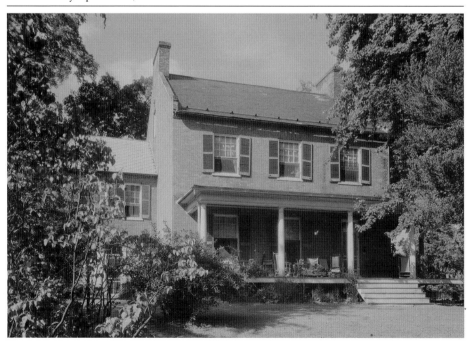

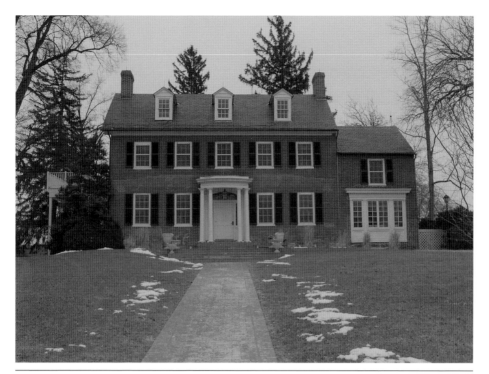

This gracious, Federal-style home was built around 1800 by Richard Thomas. Named "Woodlawn," the property once operated as a girl's boarding school, attended by young women of the privileged set, including the daughter of Francis Scott Key, author of the "Star Spangled Banner," who would make the three-hour ride from Georgetown on horseback to visit. In 1822, noted local physician Dr. William P. Palmer purchased the estate.

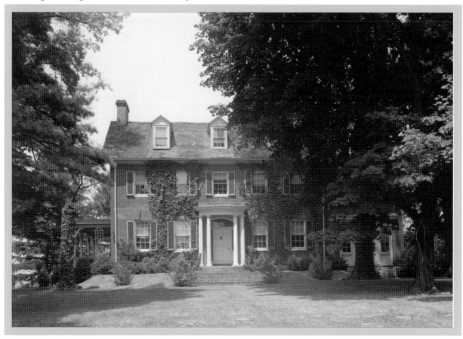

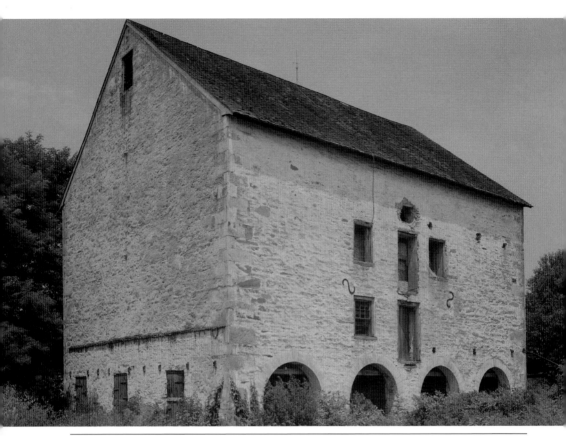

In 1832, Dr. William P. Palmer commissioned master stone mason Isaac Holland to build a substantial native-stone bank barn on his Woodlawn estate, to store wheat and hay on the upper level and house his livestock on the lower. At the country physician's death in 1867, a close friend observed, "He always made visits on horseback, and never knew any distinction between those who paid him and those he called 'God Almighty's patients.' "

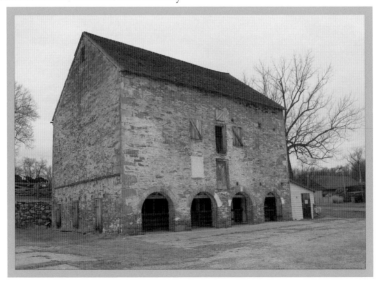

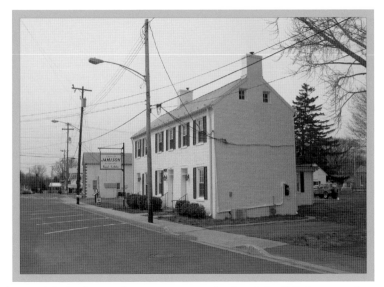

John Poole erected the first house in his eponymous town, a small log structure built in 1793. Growth was slow to come to Poolesville. By 1830, the number of houses in the rural village counted only 10, with 31 additional lots surveyed but undeveloped. By 1861, however, the town more than quadrupled in size, with over 50 buildings standing within its limits. The majority of historic houses still gracing Main Street date from this period of growth.

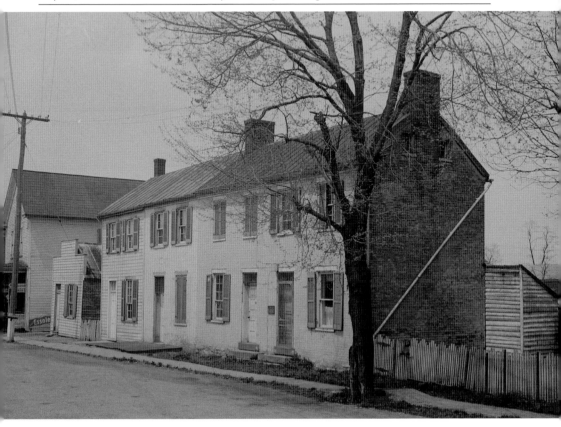

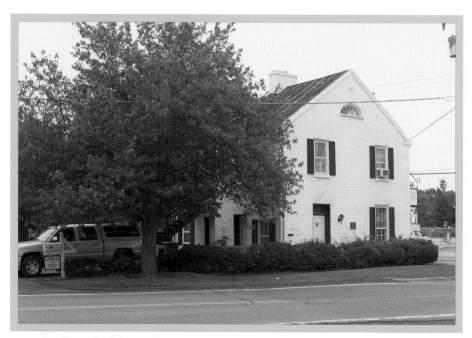

As Poolesville evolved during the 19th century, so did its homes. The first residents built simple structures of frame or log. As the families prospered, more substantial additions were attached to the homestead, with the older buildings often transformed into use as kitchen wings. Fires in 1923 and 1935 destroyed many of the town's old wood structures, altering the appearance of the village.

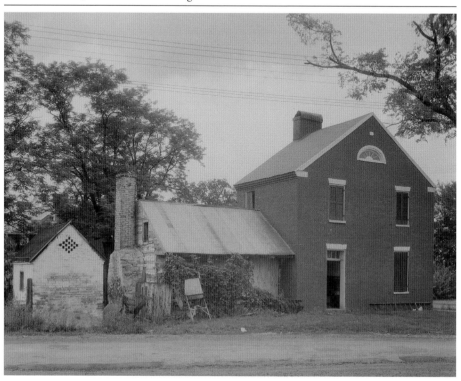

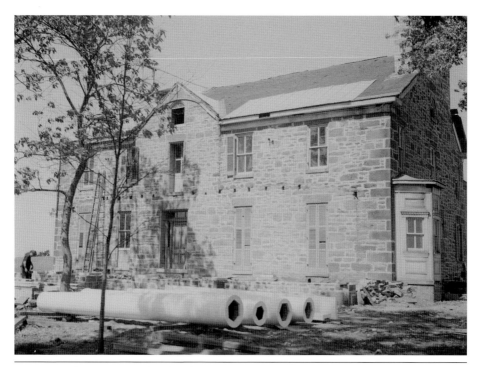

In 1831, Stephen Newton White bought a 705-acre tract near Poolesville and built a substantial stone house for his young family. Here, in 1832, their second son, Elijah Veirs White, was born; he would later become a local hero as commander of the Confederate 35th Battalion of Virginia Cavalry during the Civil War. The property, named "Stoney Castle"—remodeled in the 1930s with the addition of a large, columned portico—remained in the White family until 1949.

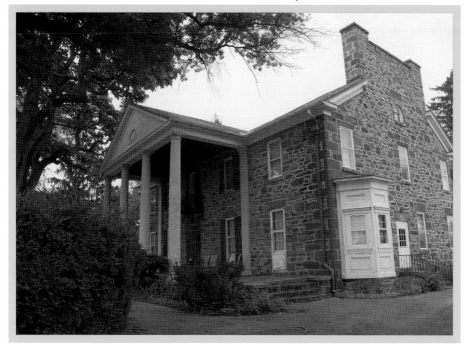

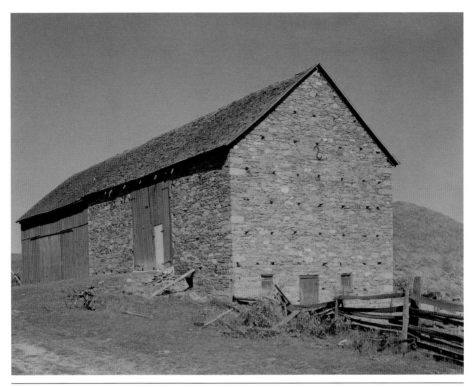

The stone barn at Rolling Acres near Unity, the 19th-century homestead of the Gaither family, was built by 1856 and is a magnificent example of a bank barn, so called because of its construction on an embankment or hill, creating a multilevel structure. The open, upper floor of the barn was used for the storage of hay and grain; the lower level contained stalls for livestock.

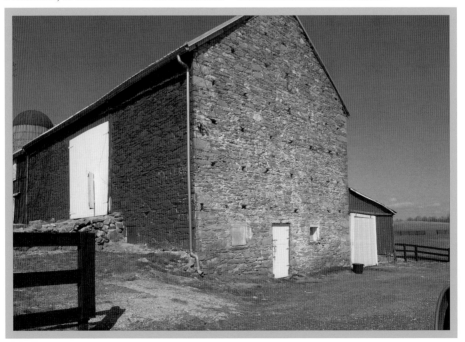

By 1890, the newly formed Chevy Chase Land Company, headed by US senator Francis Newlands of Nevada, had begun to amass property along present-day Connecticut Avenue in Montgomery County, adjoining the district boundary with the intent of creating a new suburban enclave for Washington's social and political elite. This early view of Chevy Chase's Lennox Street exemplified the community's still-evident sylvan setting.

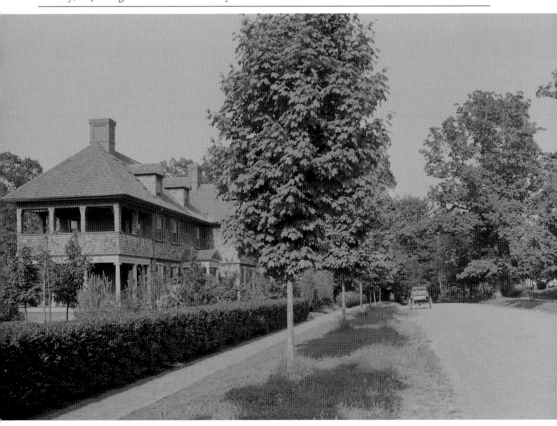

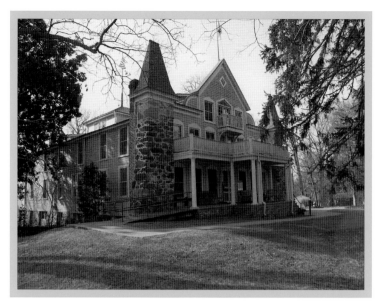

Built in 1891, this ornate Victorian structure was initially used as a storehouse for American Red Cross supplies. It was remodeled in 1897 to serve as the headquarters of the charitable organization and as a home for its founder, the Civil War nurse and humanitarian Clara Barton. Its 30 rooms were crammed with thousands of items stockpiled to help victims of war and natural disasters. Today, the restored house is a National Park Service museum.

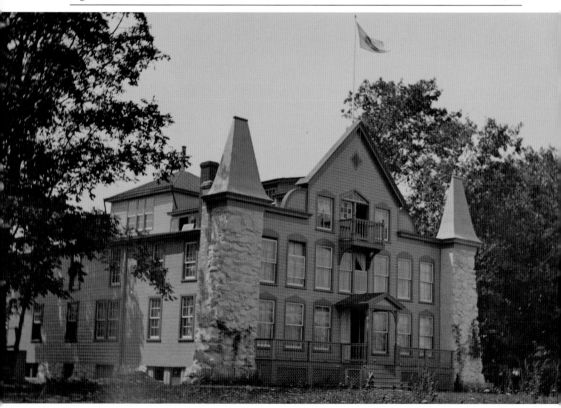

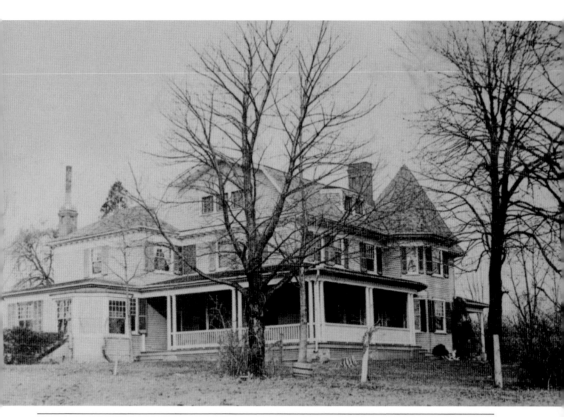

Allan Farquhar built this elaborate, Colonial Revival home in 1901. His uncle Arthur Briggs Farquhar remarked at the time that the new house was "exceedingly durable, very pleasing to the eye and comfortable and unquestionably the best residence in the neighborhood, and probably in the county, all things considered." Known as "The Cedars," the house, situated near Sandy Spring, has been the site of the Farquhar family homestead for more than 150 years.

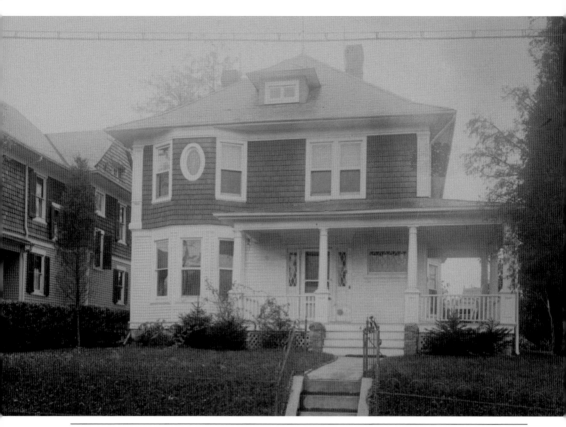

The exuberance of late-Victorian architecture, with its eclectic mixture of turrets, dormers, decorative shingles, and intricate gingerbread, gave way to more sedate styles in the early 20th century, as home designers returned to classical styles for inspiration. This home along Raymond Street in Chevy Chase reflects a studied simplicity typical of suburban Montgomery County homes in the 1920s.

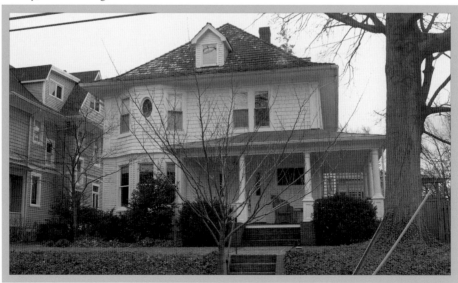

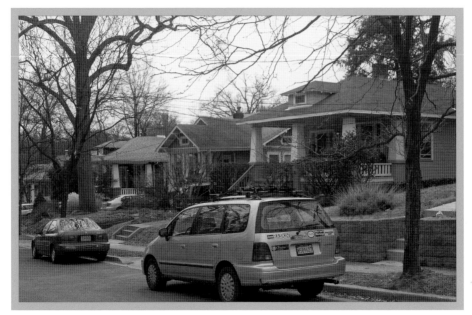

By the early 20th century, Takoma Park had grown into a bustling suburban community, sporting numerous local businesses and accessible by three trolley lines—the last of which was shut down in 1960. As of 1913, Takoma Park was the largest city in Montgomery County, and its streets, like Westmoreland, seen below in the 1920s, were lined with both old-style Victorians and new-style single-family bungalows, built long and narrow to fit the subdivided plots of land.

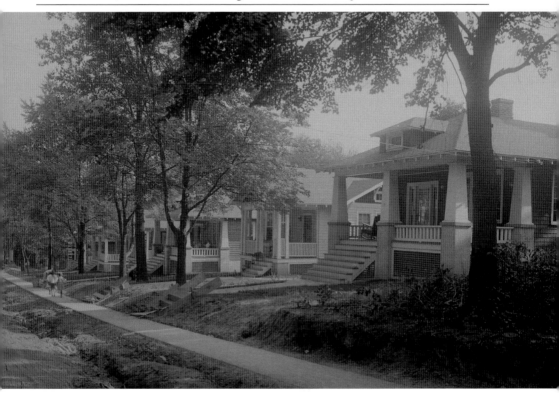

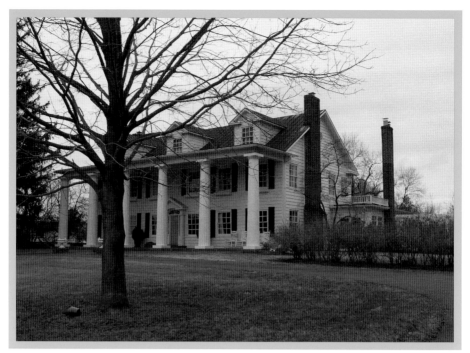

In 1926, Lionel Probert, head of the Washington Bureau of the Associated Press and vice president of the C&O Railroad, built what was perhaps the largest adaptation of a Sears Roebuck "Honor-Bilt" mail-order house, bought straight from the catalog and delivered by truck to his Olney farm.

In 1937, Harold Ickes, secretary of the interior under Pres. Franklin Delano Roosevelt, purchased the property and named it "Headwaters Farm." Today, the historic house is surrounded by the Olney Oaks subdivision.

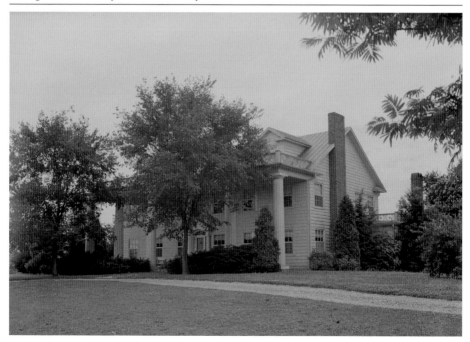

CHAPTER 2

OFF TO WORK

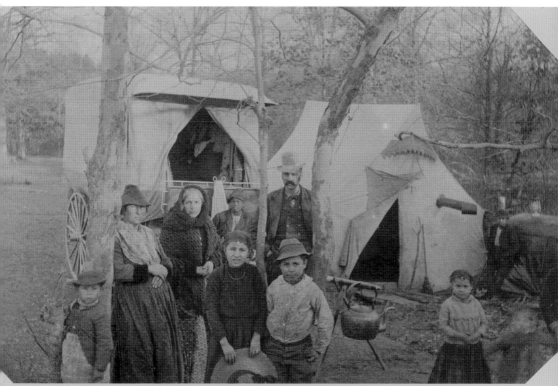

Frances Benjamin Johnston, one of America's earliest female photographers and photojournalists, captured this gypsy family encamped along Glenwood Road in Bethesda in 1888. Montgomery then was still largely rural, with agriculture the predominant industry.

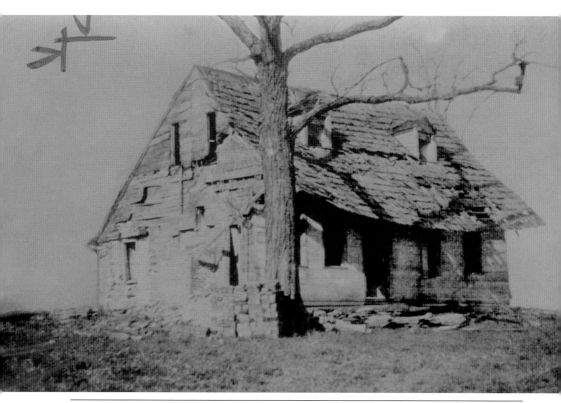

In 1753, Michael Ashton Dowden established an ordinary—an 18th-century term for a tavern and inn—along the road from Washington to Frederick (today's Route 355) near the present town of Clarksburg. In 1915, the Daughters of the Revolution placed a large boulder and plaque on the edge of the property to commemorate its history. The dilapidated tavern was torn down in 1924; today, its rebuilt frame stands in a local park.

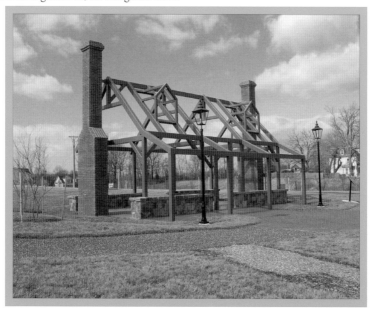

In the 1790s, Peter Kemp built a sawmill and gristmill on Paint Branch, where it crossed today's Randolph Road, just east of Colesville. The mill was rebuilt twice, the last constructed in 1879 by Franklin Pilling. The mill ceased operations by 1930. Today, the foundation has become an archeological site at the entrance to Valley Mill Park, operated by the Maryland-National Capital Park and Planning Commission.

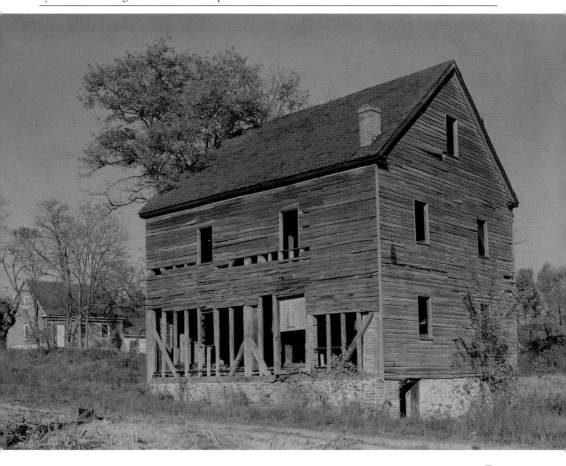

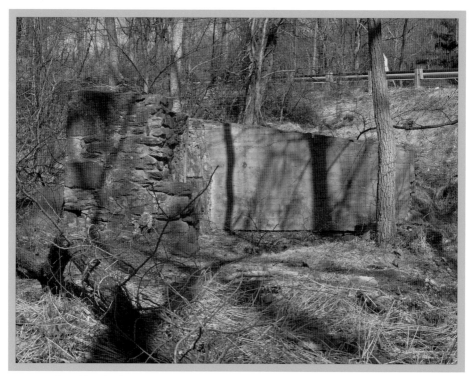

Muncaster's Mill—the first on this site dating from the early 19th century—was powered by water channeled from the nearby North Branch of Rock Creek. The waterwheel turned three "runs" of stones inside the mill building, for grinding wheat into flour and corn into meal. Typical of smaller neighborhood mills, Muncaster's eventually closed down in the 1920s. Its foundation now rests on M-NCPPC parkland, near Meadowbrook Nature Center.

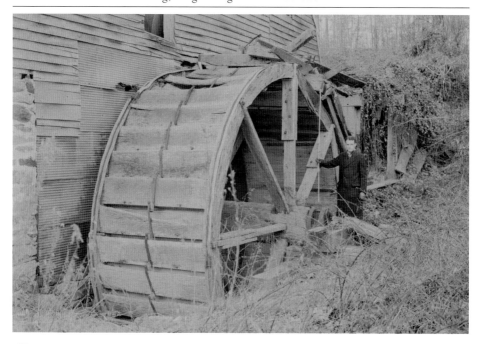

OFF TO WORK

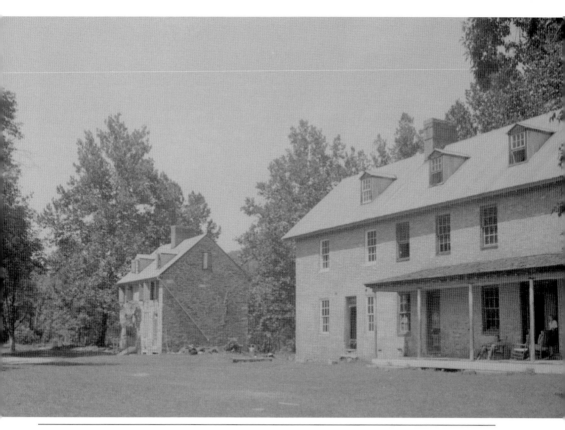

The mill town of Triadelphia, along the Patuxent River, was founded in 1809 by three brothers-in law: Thomas Moore, Isaac Briggs, and Caleb Bentley. The complex contained a cotton-spinning mill, a sawmill, a gristmill, and a mill for grinding bone and plaster, along with housing for employees, a church, company store, schoolhouse, stables, blacksmith shop, and more. Today, the village lies submerged beneath the waters of Triadelphia Reservoir.

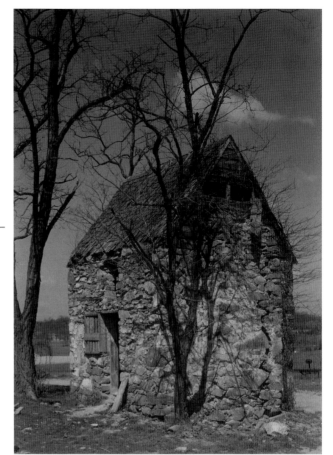

This old stone slave quarters stood on the site of today's National Naval Medical Center in Bethesda. Such dwellings were a familiar site in the county before the Civil War, when one-third of Montgomery's population was enslaved African Americans. Ground was broken for the medical center on June 29, 1939, its soaring tower following a design suggested by Pres. Franklin Delano Roosevelt.

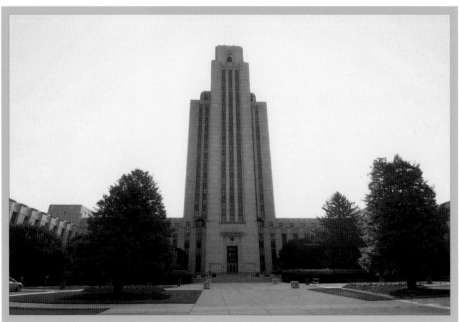

An early-20th-century streetcar loads passengers at the Montgomery County-District line, near the intersection of Georgia and Alaska Avenues in Silver Spring. By the 1890s, a spreading network of trolley lines carried passengers to and from Washington, beginning the commuter culture and spurring the suburban development of the down-county area.

In 1908, industrialist Henry Ford had introduced his affordably priced Model T automobile, and within the first year of production, more than 10,000 were sold. One of Montgomery's most popular dealers was Montgomery County Motor Co. in Rockville. By 1926, nearly 15 million Fords were rolling down America's streets—and engendering the rise of the new automobile suburbs.

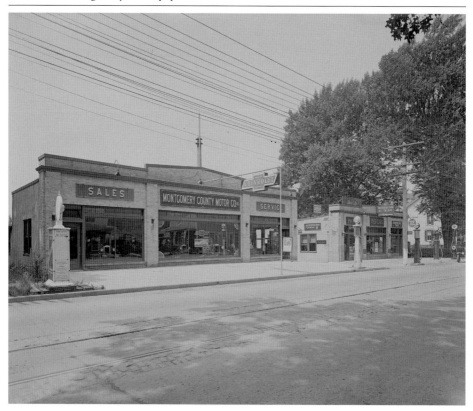

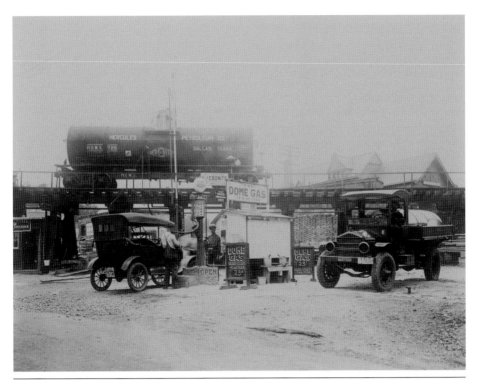

The Dome Oil Company, on the District of Columbia line near the intersection of Fourth and Cedar Streets in Takoma Park, made use of the Metropolitan Branch of the B&O Railroad for deliveries. The Takoma Park railroad station was on Cedar Street; the original grade crossing with manual gates and signals was replaced by an underpass for Cedar Street in the mid-1910s. An arsonist burned the station to the ground around 1960.

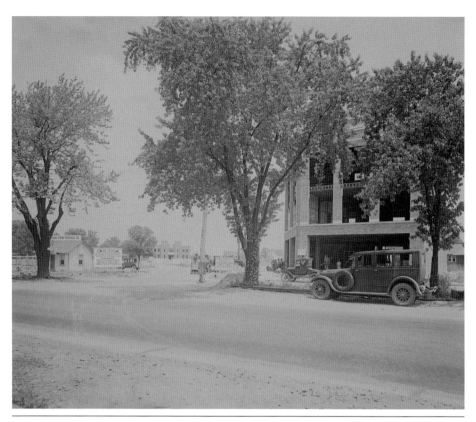

The 1927 Masonic Temple and Library Association building on the southeast corner of Georgia and Wayne Avenues in Silver Spring was designed by prominent local architect Howard Wright Cutler. The three-story brick building, trimmed in white stone, was topped by a large hall and other rooms used for lodge purposes. The building in the background is the Silver Spring Armory along Wayne Avenue, also constructed in 1927.

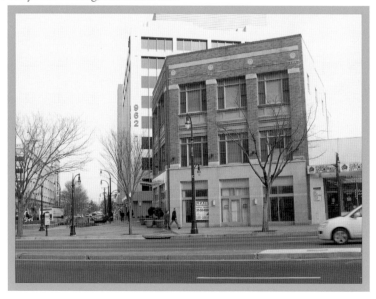

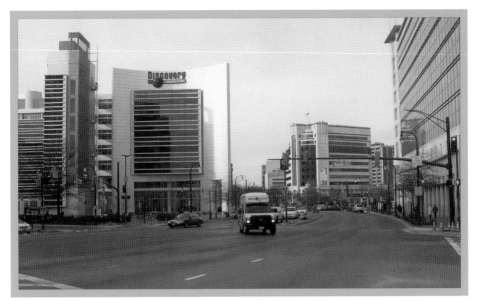

The building hosting the chicken dinner was the Knights of Columbus Hall, along Georgia Avenue in Silver Spring. Built around 1926, the building was sold four years later and remodeled for use as a house of worship by the newly founded St. Michael's Parish. In 1952, the congregation moved to its present home on Wayne Avenue. Today, the site is occupied by the headquarters of the Discovery cable network.

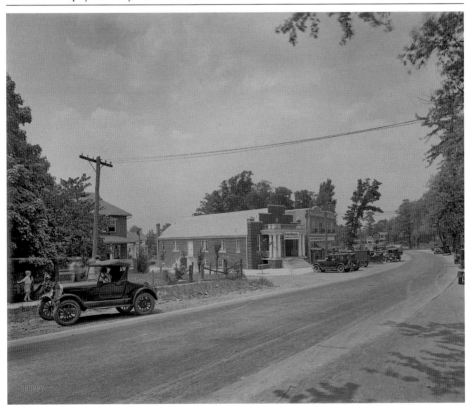

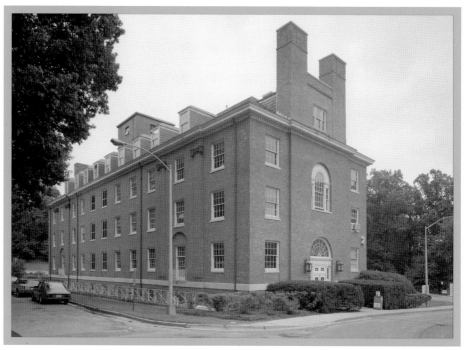

In 1935, the Wilson family made a gift of 45 acres of their Bethesda estate, "Tree Tops," for use as a new campus for the National Institutes of Health. The cornerstone for the first structure was dedicated in 1938; within 10 years, federal use of the complex along Rockville Pike had expanded so rapidly that additional acreage was needed to accommodate the growing collection of research buildings.

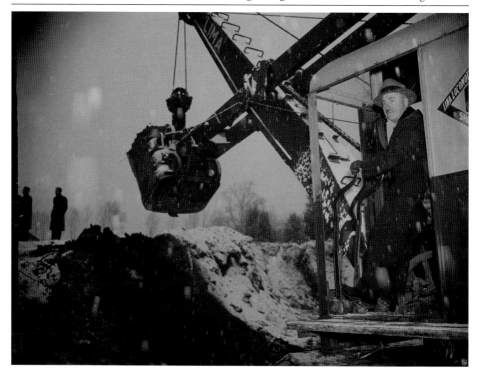

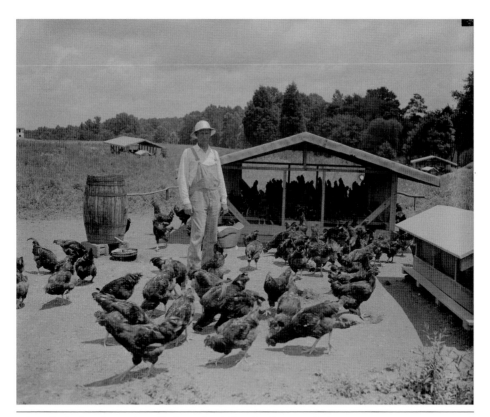

Edgar Charles "Sam" Rice, the Hall of Fame baseball player, roamed the outfield for the Washington Senators from 1915 to 1933, leading the team to a World Series championship in 1924. Following his playing days, he retired to his farm near Ashton, bordering today's Tree Lawn Drive. Rice raised his chickens hygienically, selling the eggs for a dollar apiece to the National Institutes of Health in Bethesda for virology vaccine research.

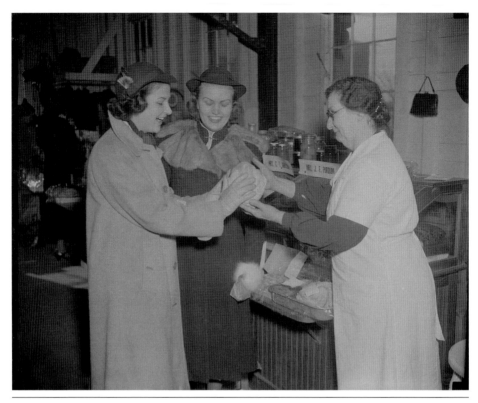

While the Great Depression of the 1930s crippled communities across America, the large number of government paychecks filling the coffers of Montgomery businesses helped insulate the county from severe economic conditions. Area farmers banked on the county's financial strength with the establishment of the Farm Women's Cooperative Market in Bethesda in 1932, a self-help project selling locally grown produce. The market still operates today.

CHAPTER 3

BODY, MIND, AND SPIRIT

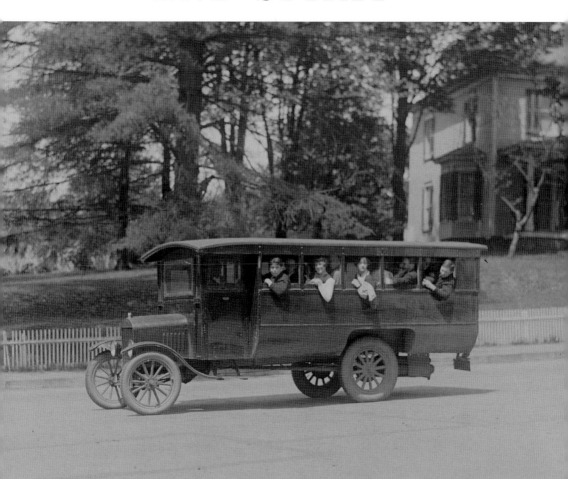

A Ford Motor Company bus rumbles down the streets of Rockville in 1925, shuttling children to and from area public schools. A countywide system of free primary and secondary schools—for white children—did not emerge until 1860. In 1872, the Maryland State Assembly appropriated the first funds for schools for African American children. In that year, Montgomery created a segregated school system, which would remain in existence until 1958, when the last school was integrated.

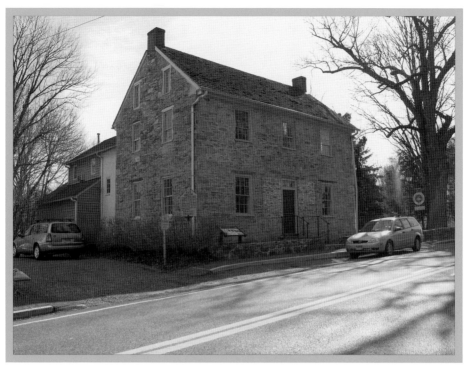

Founded in 1808, the Brookeville Academy was one of the county's earliest private schools. The first floor of the stone schoolhouse was completed in 1810; the second story was added in 1840. The building later served the Odd Fellows, American Legion, and St. John's Church as a meeting place. Today, the restored building, owned by the Town of Brookeville, has become a lively community center.

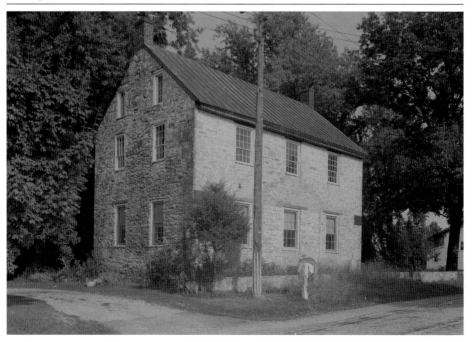

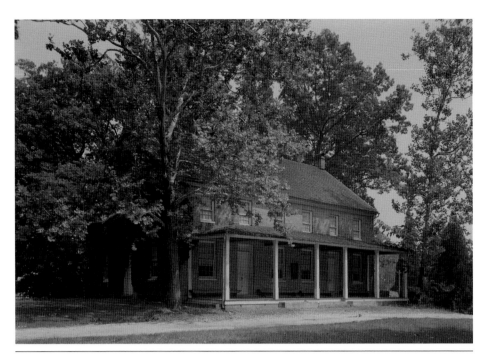

The Sandy Spring Friends Meetinghouse was built in 1817 to serve the spiritual needs of the surrounding Quaker community. The large, Flemish-bond brick building was erected near a freshwater spring, which gave the village its name. In the late 19th century, a private school was established nearby, named Sherwood Academy. The school was turned over to the county in 1906 to become Sherwood High School—Montgomery's third public high school.

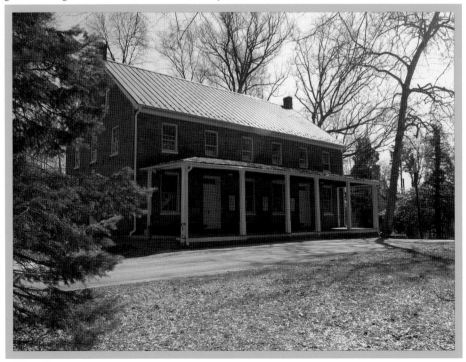

Local residents Dr. Josiah Harding, Elizabeth Blair Lee, and Oliver H.P. Clark founded Grace Episcopal Church in the Woodside community just north of Silver Spring in 1855. The first church, standing along Georgia Avenue and consecrated in 1857, burned to the ground in 1896 and was replaced by this brown-shingled structure designed by Clarence L. Harding. Post–World War II suburban development swelled the congregation and prompted construction of the current building, completed in 1956.

BODY, MIND, AND SPIRIT

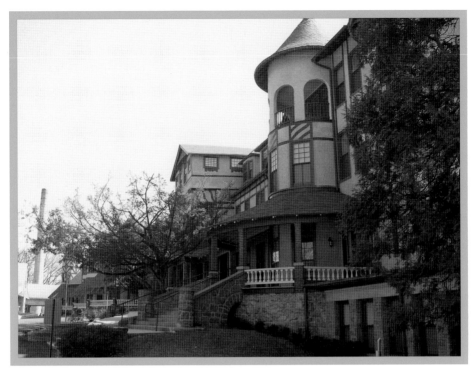

By 1894, the Forest Inn, a fanciful resort hotel near Forest Glen, had been transformed into the National Park Seminary, a sylvan seat of elucidation and refinement for young women, mostly high school graduates who came for "finishing" and college preparation. Today, much of the historic school property has been transformed into an upscale housing development, with the sprawling main building renovated for use as apartments.

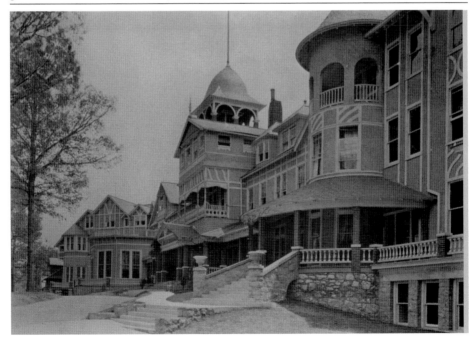

"Soul training is the special feature of our school," the National Park Seminary declared, with the inculcation of the finer arts—cultural, social, domestic—the daily objective. Here, privileged young women in the early 1900s enjoy a festive dance around a Maypole. During World War II, the school was commandeered by the US Army as an annex to Walter Reed Hospital, for use as a convalescent home for wounded warriors.

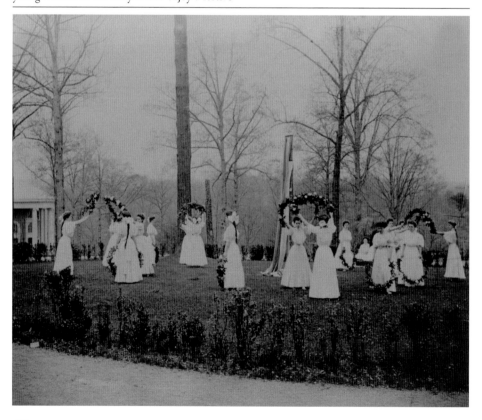

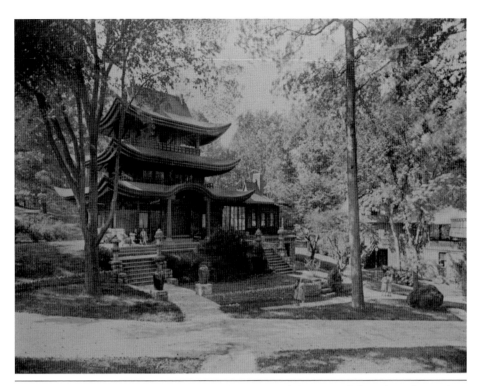

Students at National Park Seminary were divided into eight sororities, and by 1905, each had its own distinctive clubhouse, "a miniature World's Exposition in national styles," as an early publication noted. Among others, there was a Dutch windmill, a Swiss chalet, an English castle with a working drawbridge, and this three-story Japanese pagoda, all designed by noted Philadelphia architect Emily Elizabeth Holman. Today, the clubhouses are being converted into single-family dwellings.

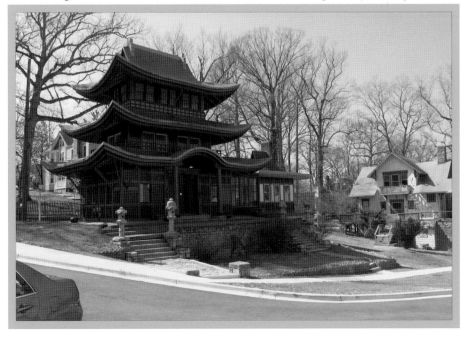

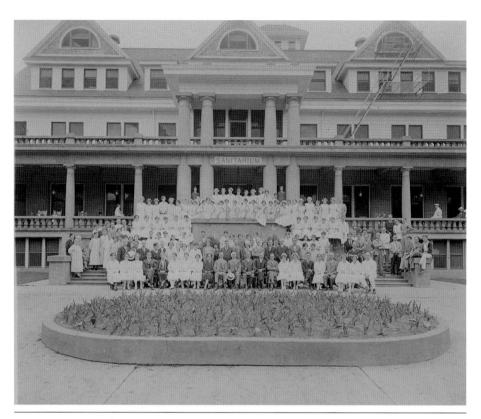

In 1903, a group of Seventh-day Adventists purchased a plot of land overlooking Sligo Creek in Takoma Park for use as a wellness center. The high elevation and sylvan setting was thought to be a healthier environment than the city. In 1907, the facility opened as Washington Sanitarium—the oldest medical facility in Montgomery County. The San, as it was called, eventually became Washington Adventist Hospital.

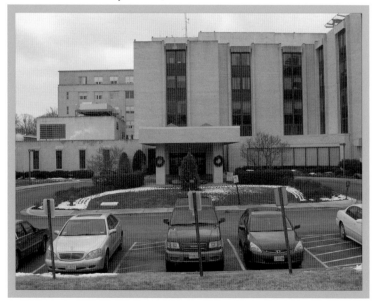

In 1908, the Bliss Electrical School purchased the 15-year-old North Takoma Hotel, at the corner of Takoma Avenue and Fenton Streets in Takoma Park, and opened its doors to an inaugural class of students anxious to join the burgeoning ranks of electrical engineers. Fire destroyed the renovated school later that year, and the school was substantially rebuilt. The Montgomery College campus now occupies the site.

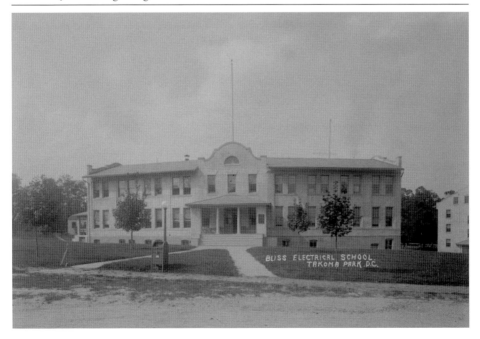

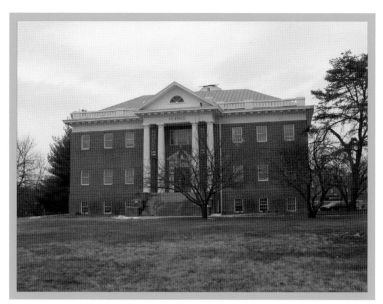

Washington Adventist University in Takoma Park was established in 1904 by Seventh-day Adventists. First known as the Washington Training Institute, its original aim was to provide a liberal arts education for young men and women—with a later focus on special training for missionaries. In 1961, the college, adjoining the grounds of Washington Adventist Hospital, changed its name to Columbia Union College. With the achievement of university status in 2009, the college was renamed Washington Adventist University.

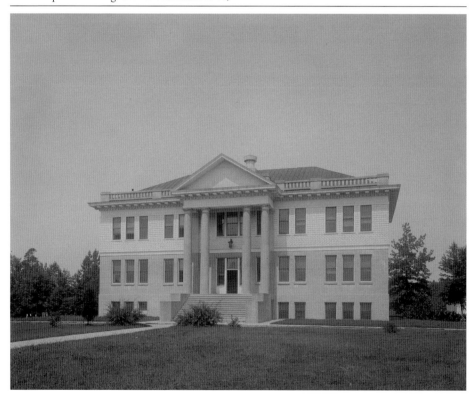

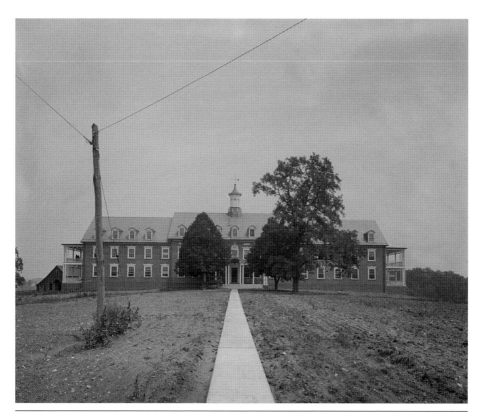

Founded on the grounds of the "Rolling Acres" dairy farm in Gaithersburg, Asbury Methodist Village first opened in 1926 as the Methodist Home for the Aged. Today, the original building, located near Lakeforest Mall, has become the centerpiece of a large and lively community serving the needs of seniors of all denominations.

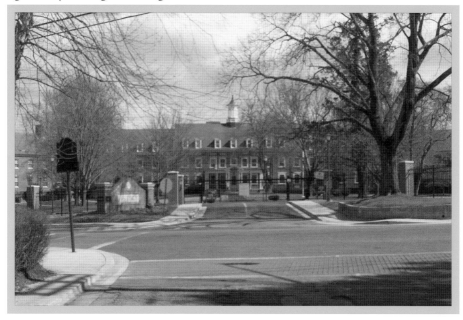

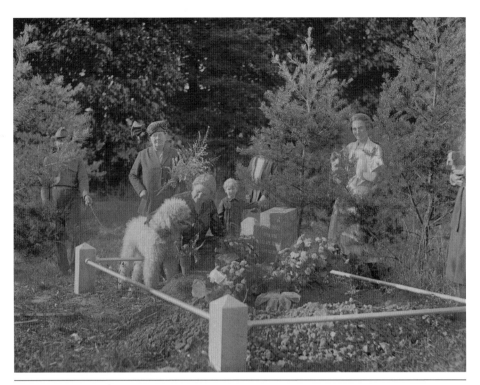

Selma Snook of Washington lays to rest her dear departed dog, Buster, at a funeral ceremony held in 1921 at the newly opened Aspin Hill Cemetery. Reportedly America's second oldest pet cemetery, the grounds contain more than 40,000 burials, including 40 humans who insisted upon being interred alongside their pets. Bankrupt by the 1980s, the overgrown cemetery was slated to be turned into a shopping center but was saved from destruction by People for the Ethical Treatment of Animals.

GOOD TIMES

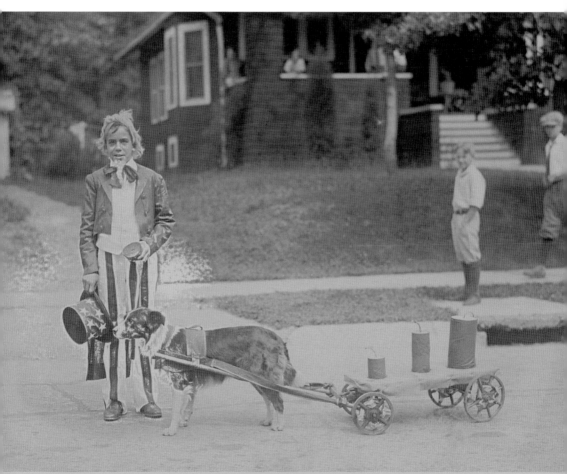

A young boy and his dog prepare for the Fourth of July parade in downtown Takoma Park in the mid-1920s. The town emerged at the intersection of Montgomery County, Prince George's County, and the District of Columbia, spilling over the borders and split into districts. By the end of the 20th century, the Prince George's portion of the town had been annexed to the Montgomery County portion, unifying the two sections under a single jurisdiction.

Since the mid-19th century, an annual county fair was held in Montgomery County for four days in the month of August. Families came in wagons and carriages to the Rockville fairgrounds and stayed for the duration. Harness racing was one of the main attractions, but after the introduction of the automobile in the early 20th century, car races took over. In 1946, after the construction of Richard Montgomery High School, the old track became a football field and stadium.

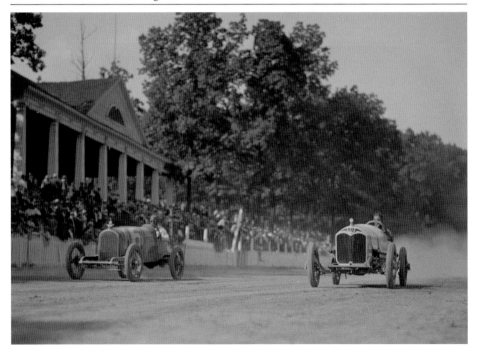

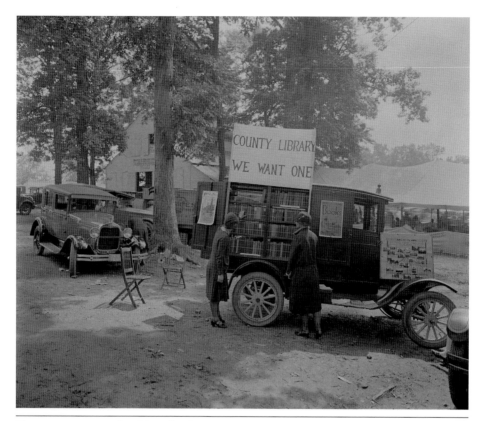

The Montgomery agricultural fair offered a range of exhibitions, including showings of prized livestock and poultry, homegrown produce, baked and canned goods, and more. The fair as well provided an opportunity for local interest groups to tout their cause, such as the group here in 1925 advocating for a public library system. As times changed, the fairgrounds lost its appeal to more sophisticated and commercialized sites.

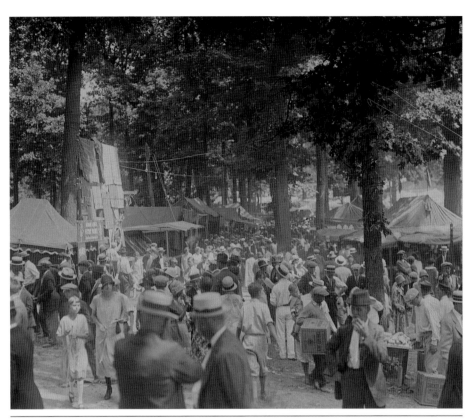

The original Montgomery agricultural fair, seen here in the 1920s, was a festive event, eliciting exuberant displays from all sectors of the community. The fair shut down in the early 20th century, but after years of dormancy, it was revived out of the desire of 4-H leaders to provide a county show for its members. In 1949, new fairgrounds were opened in Gaithersburg—and went on to become the largest county fair in the state of Maryland.

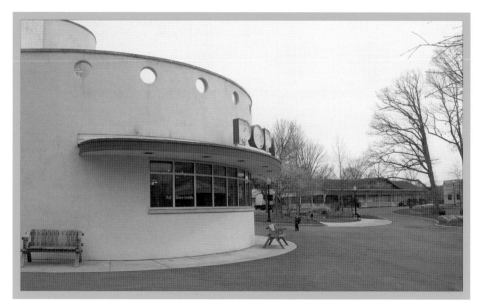

In 1891, twin brothers Edward and Edwin Baltzley opened the National Chautauqua at Glen Echo, a sprawling complex intended to be a "center of liberal and practical education, especially among the masses of people." Rustic stone buildings designed by Victor E. Mindeleff distinguished the educational institution. The enterprise lasted less than two years, and in 1899, the Balztleys rented the property to the Glen Echo Company, which transformed it into an amusement park. Art Deco–style buildings replaced the earlier stone ones.

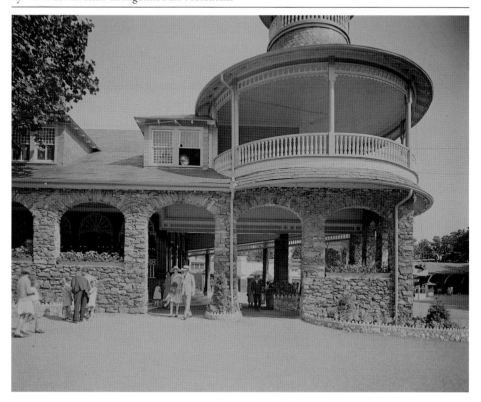

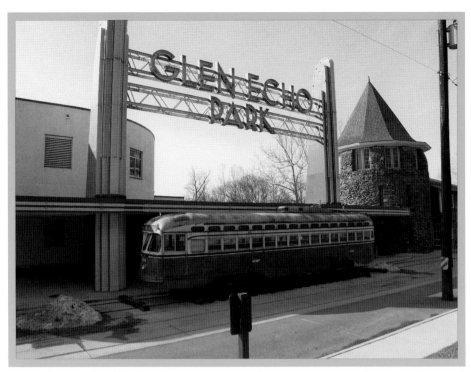

In 1903, the ownership of the Glen Echo amusement park property was transferred to the Washington Railway and Electric Company, which operated the trolley running from Washington, DC, to the park entrance gate. The stone turret at the park's entrance, built in 1891, was a holdover from its earlier incarnation as a Chautaqua educational center. Admission to the park was free; profits came from trolley fares as well as the park's rides, games, and concessions. Today, the property is a national park.

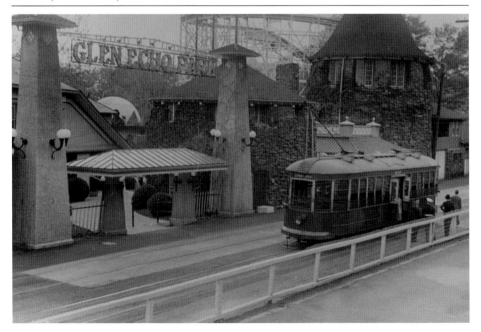

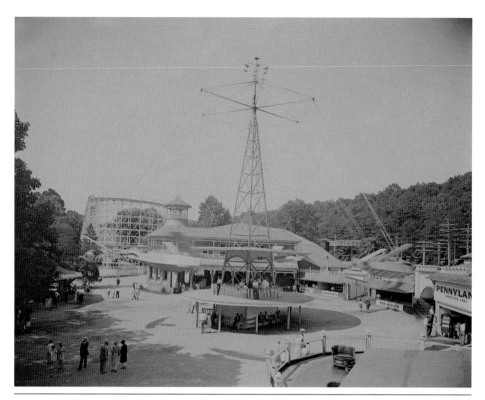

In its peak years in the early 20th century, attendance at Glen Echo Park averaged 400,000 per year. Each season, the owners attempted to keep the park fresh and entertaining by offering one new attraction, something intriguing to entice return visitors. Washington-area residents thrilled at riding above the park in the flying Gyroplane, introduced in 1913.

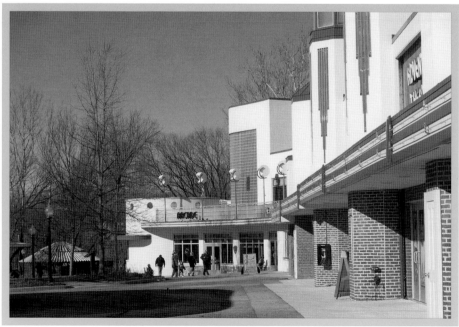

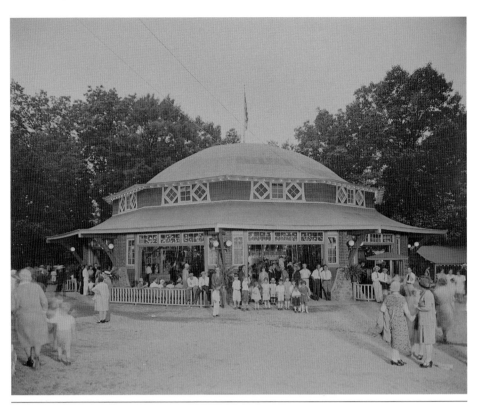

Installed in 1921, the 12-sided canopy and carved figures of the Glen Echo Park carousel were made by the Dentzel Carousel Company of Germantown, Pennsylvania, famous for their fanciful rides. In 2003, a 20-year restoration project was completed, bringing the carousel back to its original beauty. The carousel still runs today, operated by the National Park Service.

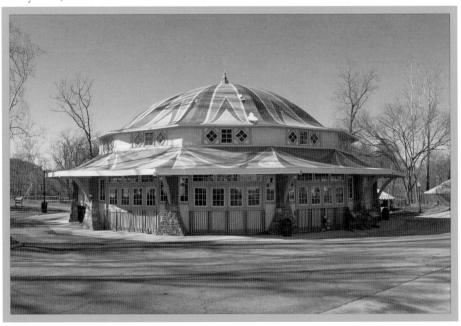

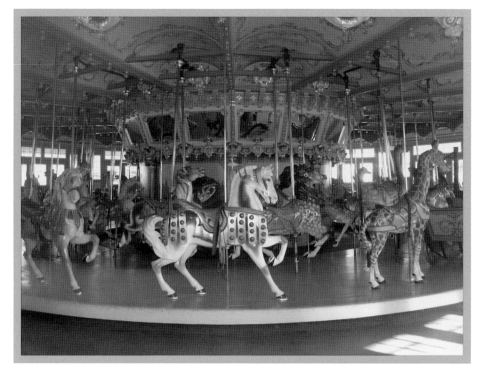

Dentzel carousels were renowned for their elaborate, hand-carved animals and effusive ornamentation. The Glen Echo carousel falls into a category referred to as a "menagerie carousel," due to its many different animals, spinning in a circle and undulating to music. Riders still can choose from 40 horses, 4 rabbits, 4 ostriches, a giraffe, a deer, a lion, and a tiger.

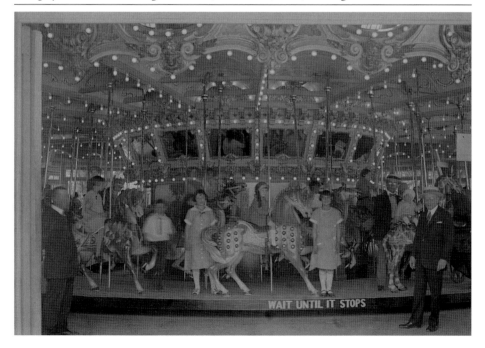

In 1921, the Coaster Dips was added to the growing number of attractions at Glen Echo Park, expanding its luster as one of the most popular amusement attractions in the Washington, DC, area. However, tastes in entertainment changed in the last half of the 20th century. Attendance declined precipitously, and at the end of the 1968 season, the owners announced the park closed. Today, the property is operated by the National Park Service as a cultural arts center.

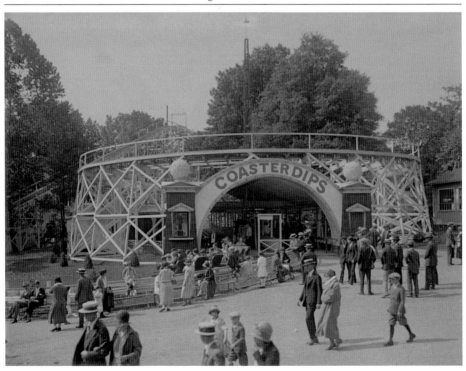

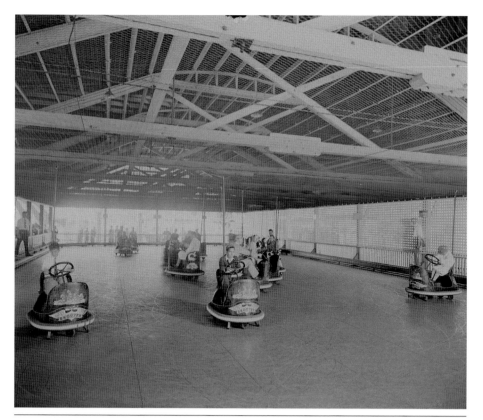

In 1923, the bumper car ride was installed at Glen Echo Park. Originally known as the Scooter and powered by overhead electrical wires—much like Montgomery's early trolleys—the popular ride's pavilion was later given an Art Deco touch and renamed the Dodgem, featuring fanciful eagles applied on each decorative pillar. Today, the bumper car pavilion serves as an all-purpose venue for the cultural park's myriad activities.

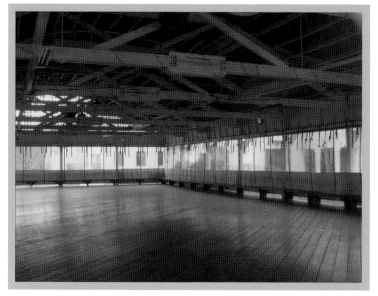

In 1911, Glen Echo hired experienced amusement park expert and promoter Leonard B. Schloss as its general manager. Schloss presided over the park's expansion through the first half of the 20th century, finally retiring in 1950. Early advertisements touted the park as an ideal family resort, fashioned after Atlantic City, New Jersey, and Coney Island, New York. In the 1970s, unusual buildings called "yurts" were built on the site of early attractions.

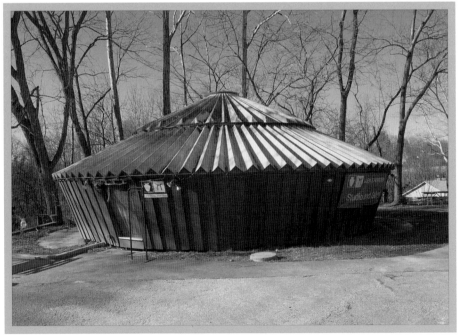

Realizing that the Cabin John Bridge—at its completion in 1864 the longest single-span stone arch in the world—was becoming a noted tourist attraction, Joseph and Rosa Bobinger bought a tract of land next to the bridge in 1870 and built and operated a successful hotel. Around 1901, the hoteliers hired a local carpenter to design and build rustic cedar gazebos at scenic spots on the grounds. The hotel closed in the late 1920s; the forest has reclaimed its site.

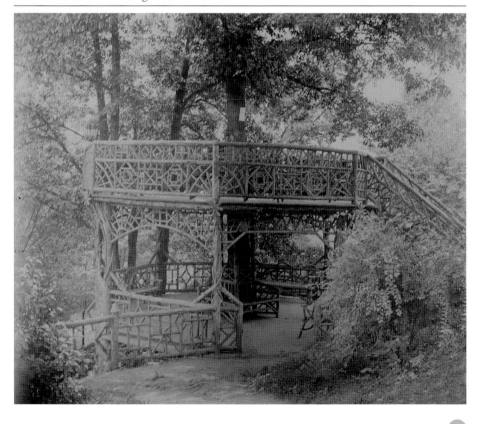

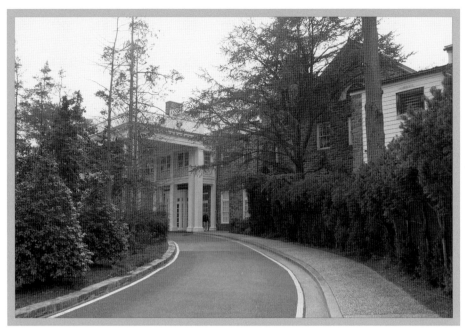

In 1911, renowned architect Henri de Sibour designed a new clubhouse for the Chevy Chase Club, an impressive Colonial Revival building fronting the west side of Connecticut Avenue. A porte-cochere was added in 1914; a gazebo at the trolley stop in front of the club was built the following year. After World War I, membership expanded, necessitating a larger clubhouse, and in 1926, Washington architect Waddy Wood was retained to redesign and enlarge the building.

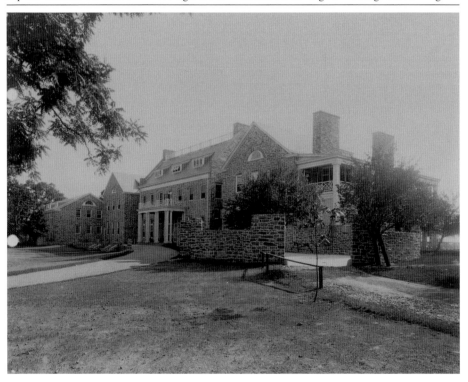

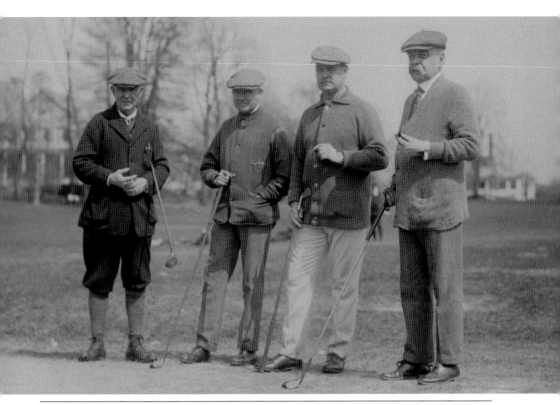

Enjoying a golf outing at the Chevy Chase Club in 1920 are, from left to right, Secretary of the Interior Judge John Barton Payne, Moreven Thompson of Washington, DC, Secretary of the Treasury David Franklin Houston, and ex-senator Willard Saulsbury. The original six-hole course, laid out in 1895, had the first tee on the west side of Connecticut Avenue. Golfers were required to drive the ball across the road to reach the first green on the other side. By 1898, an 18-hole course had been created entirely on the west side of the avenue.

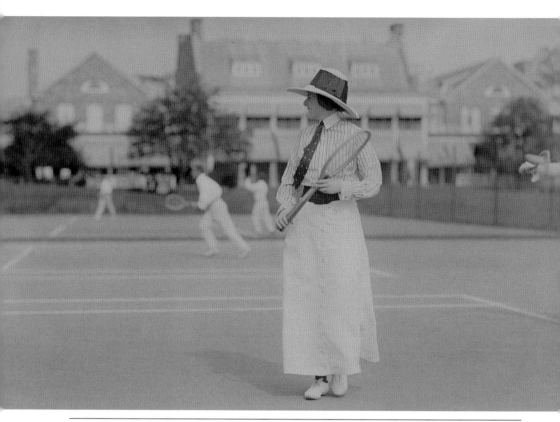

Women dressed in their finest tennis togs enjoy a match at the Chevy Chase Club around 1915. By 1905, the club had expanded its recreational offerings to include tennis, squash, baseball, and croquet courts, along with four bowling alleys.

Beginning in 1960, the club undertook a substantial remodeling, with an entirely new winter sports center on the site of the old bowling alleys and enlarged wings of the main clubhouse, establishing its current appearance.

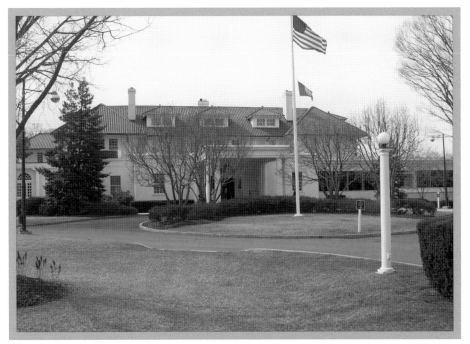

In 1898, nine Washingtonians organized the Columbia Golf Club, converting a vacant field along Georgia Avenue into a crude nine-hole course. Ropes were put in place around the putting greens to prevent livestock from straying onto the newly planted turf. In 1909, the club purchased a large parcel along the west side of Connecticut Avenue in Chevy Chase and two years later hired architect Frederick B. Pyle to design a new clubhouse, opened to members in January 1911.

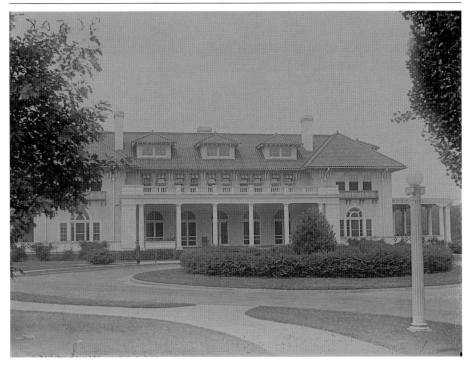

Red Cross volunteers mount a donation drive on the golf course of the Columbia Country Club in Chevy Chase during World War I. The course, designed by noted golfer Walter Travis, was one of the favorite courses of Pres. Woodrow Wilson and hosted the 1921 US Open tournament, where Pres. Warren Harding presented the Champion's Trophy. Legend has it that the par-three 16th hole served as Bobby Jones's inspiration for the 12th hole at Augusta National Golf Club.

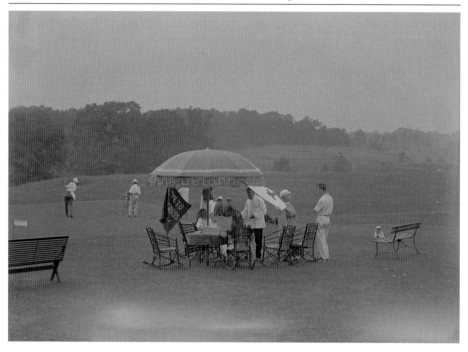

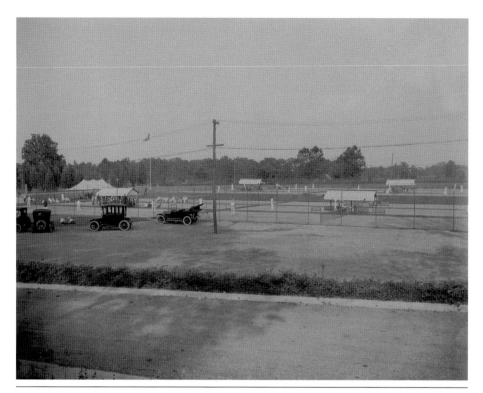

Members of Columbia Country Club in Chevy Chase had an abundance of tennis courts from which to choose in the early 20th century. The sport had been a favorite of both men and women since the club took up permanent residence at the northwest corner of Connecticut Avenue and East-West Highway in 1909. Platform tennis courts were added in the 1960s.

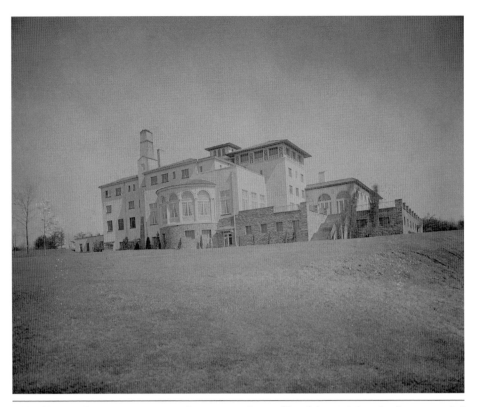

Officially opened in 1924, Congressional Country Club was the creation of two Indiana congressmen, Oscar Bland and O.R. Luhring, who envisioned the club as a private place where Washington's political and social elite could gather to mix business with pleasure. The Mediterranean-style clubhouse, designed by Philip M. Julien, has been expanded and renovated over the years. Today, the building, a mosaic of blue gray stone, white marble aggregate, and Italian red tile, covers 114,000 square feet on six levels.

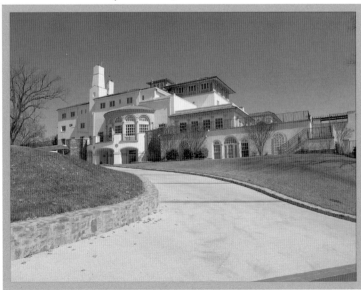

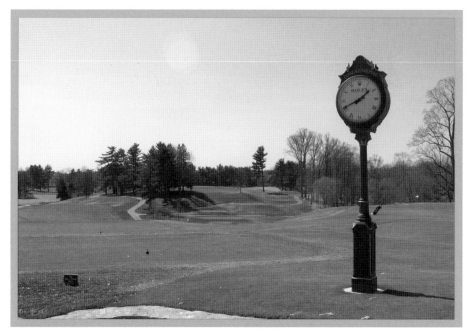

A foursome prepares to hit the links at Bethesda's Congressional County Club, around the time of its opening in 1924. The club listed five former US presidents among its founding life members— Woodrow Wilson, William Howard Taft, Warren Harding, Calvin Coolidge, and Herbert Hoover.

The club's original course, laid out by noted designer Devereux Emmet, had been open for nearly a year before the rest of the facility and gained fame as a fast track, filled with blind shots and treacherous greens.

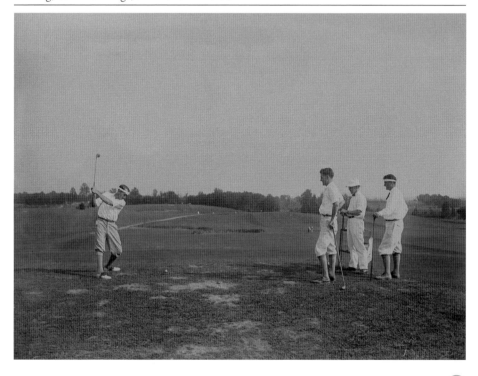

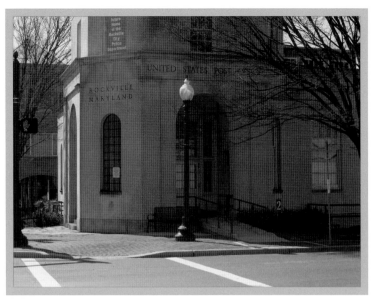

The opening of the new Rockville Post Office in 1939 was disrupted by a neighbor, Mrs. Samuel Wimsatt, who claimed that one-seventh of the property upon which the post office was built was still hers, because it was not legally bought by the federal government. The morning of the dedication, she posted "No Trespassing" signs and threatened to have any visitors to the post office locked up. No arrests were made, and the issue faded away.

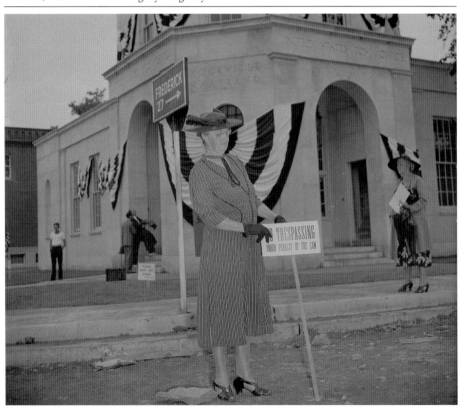

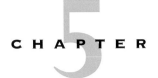
WATER'S EDGE

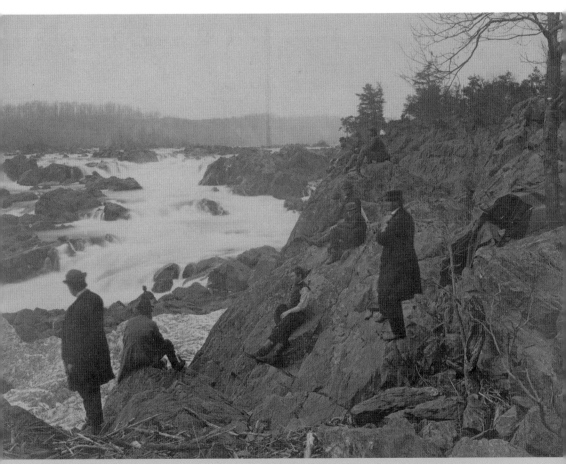

Sightseers in 1864 take in the grandeur of the Great Falls of the Potomac. One of the Washington area's most spectacular natural landmarks, the falls have been a popular tourist attraction since the 18th century. Here, the Potomac River builds up speed and force as it rushes over huge boulders and jagged rocks, dropping 76 feet in less than a mile—the steepest fall line rapids of any eastern river.

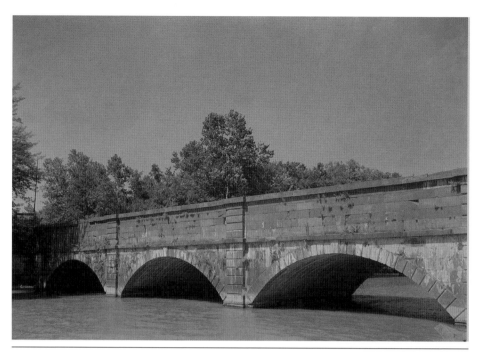

Begun in 1828, completed in 1850, and eventually running 185 miles from Washington, DC, to Cumberland, Maryland, the Chesapeake and Ohio Canal was one of the 19th century's more ambitious industrial experiments. The Seneca Aqueduct, opened in 1833, is the only place along the C&O Canal where an aqueduct and a lock were built as a single structure. The upstream arch was washed out by a local flood in 1971; a wooden footbridge now completes the crossing over Seneca Creek.

WATER'S EDGE

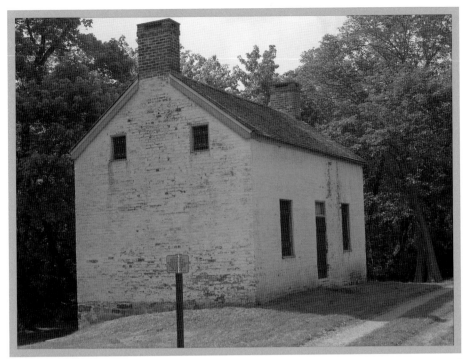

All along the canal, lockkeepers, quartered in company-built houses sitting nearly atop the stone locks, like this one at Edward's Ferry, operated the giant wooden gates that trapped and released water, allowing barges to pass through to the next section. A small community sprang up around the lockhouse and lock in the 19th century, with stores and warehouses servicing the barges on the canal.

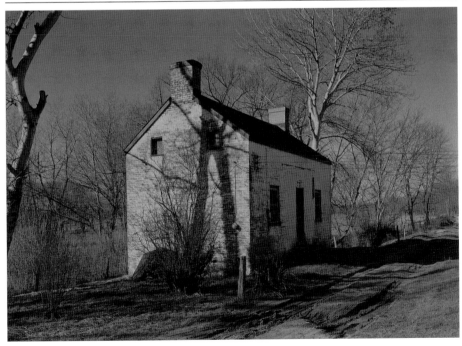

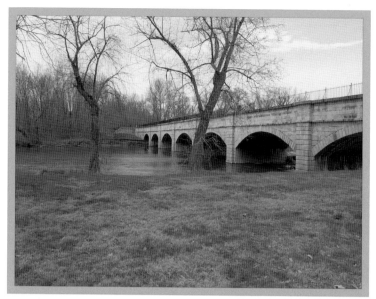

Monocacy Aqueduct, on the border of Montgomery and Frederick Counties, carries the C&O Canal across the Monocacy River. The seven-arch, 560-foot aqueduct, built of pink quartzite between 1829 and 1833, is the longest along the canal. Constant floodwaters so imperiled the aqueduct that the National Trust for Historic Preservation placed it on its Top 10 list of endangered sites. The C&O Canal Association, working with the National Park Service and others, raised the money that saved it from oblivion.

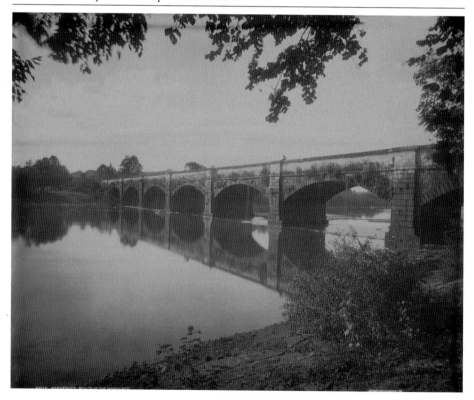

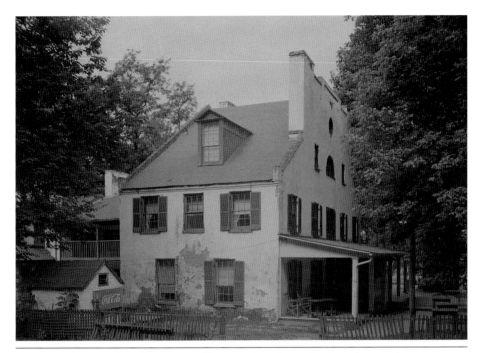

The Great Falls Tavern along the C&O Canal began in 1828 as a simple stone locktender's house. By the 1830s, the building had been substantially expanded and converted to use as an inn, catering to travelers along the canal and to sightseers who came to view the spectacular falls of the Potomac River. Today, the National Park Service operates the tavern as a visitor center and museum.

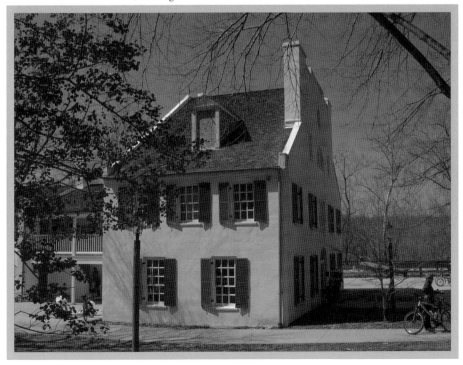

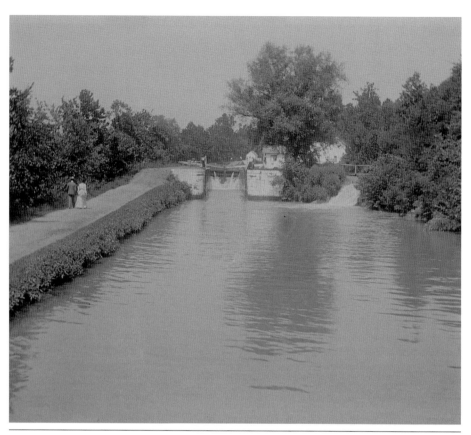

Situated along Lock 18 of the C&O Canal, below Great Falls, was a waste weir—a drain built to release water in times of flooding. This particular weir was part of the Washington Aqueduct system, discharging water into the canal when the water level rose—and oftentimes causing the canal itself to overflow its banks. Its walls today are a patchwork replacement of concrete and brick.

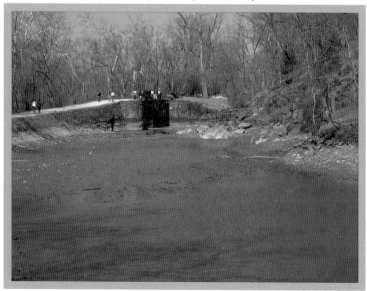

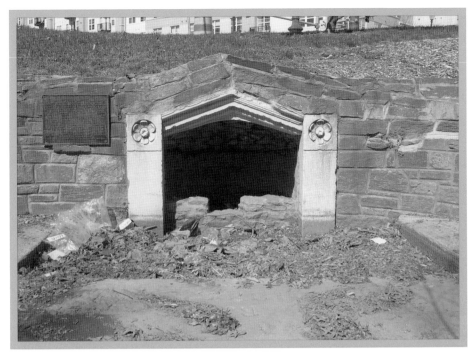

In 1840, Francis Preston Blair, a Washington publisher and politico, was riding with his daughter Elizabeth when they discovered a flowing spring that dazzled from mica chips in the water. Two years later, he completed near the site a 20-room mansion he dubbed "Silver Spring" for the sparkling water.

The house was torn down in 1954; the site of the spring—since dried up, its stone wall replaced, and statue missing—is now part of Acorn Park, named for an unusual acorn-shaped gazebo from the original estate.

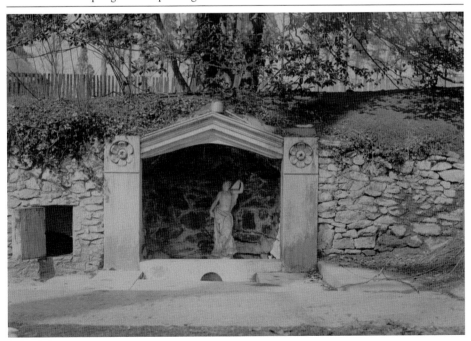

Cabin John Creek was once navigable far inland, as seen below in the early 1900s; today, development has constricted its flow. The source of the creek's name—also known as Cabin John's Run and Captain John's Branch—is a mystery. Some say it refers to a hermit named John who lived nearby. Others attribute it to Capt. John Smith, who, in 1608, became the first European to visit the area.

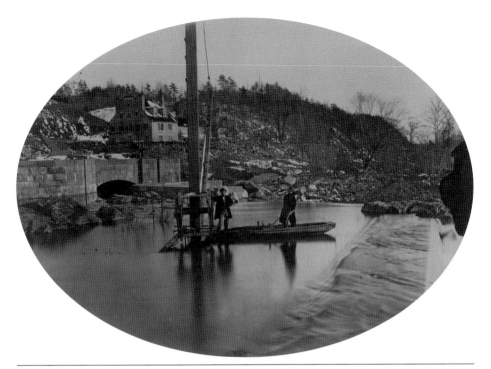

In November 1853, ground was broken at Great Falls, Maryland, for a public water system for Washington. The plan was to divert water from the Potomac River into a brick conduit, which would carry the water to city pipelines. The 12-mile-long aqueduct began carrying water to the Georgetown reservoir in 1864, about the time of this photograph. In the 1970s, an observation deck overlooking the Potomac was built on the original location of the intake dam.

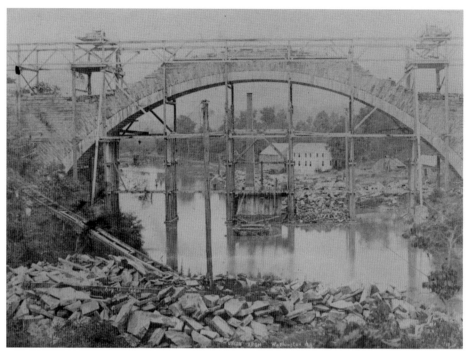

Construction of the Cabin John Bridge—officially known as the Union Arch Bridge—was begun in 1857, designed as part of the Washington Aqueduct system that carried the city's water supply from its intake at Great Falls to the reservoir at Georgetown. The bridge was designed by Alfred Landon Rives and built by the US Army Corps of Engineers, under the direction of Lt. Montgomery C. Meigs.

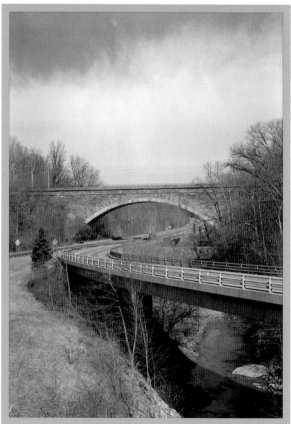

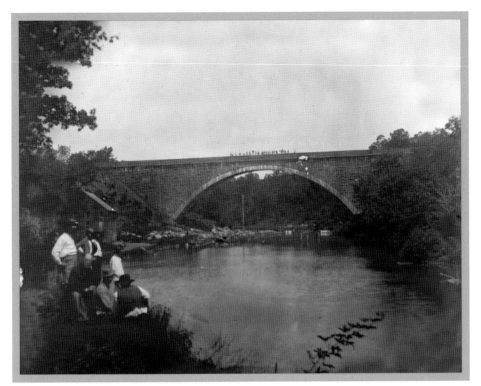

At its completion in 1864, the main span of the Cabin John Bridge, constructed of sandstone and granite, was the longest single-span masonry arch in the world. It retained that distinction until the opening of the 218-foot span of the Pont Adolphe Bridge in Luxembourg in 1903. Union soldiers kept watch over the bridge during the Civil War, protecting it from Confederate saboteurs.

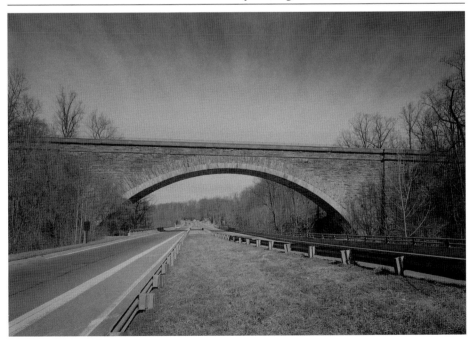

A stone tablet on the Cabin John Bridge originally contained a listing of the political leaders that were in office at the start of the project, including Pres. Abraham Lincoln and Secretary of War Jefferson Davis. By 1862, Davis had left the Union to become president of the Confederacy; his name was summarily removed from the bridge. In 1908, Pres. Theodore Roosevelt ordered that Davis's name be reinscribed on the tablet.

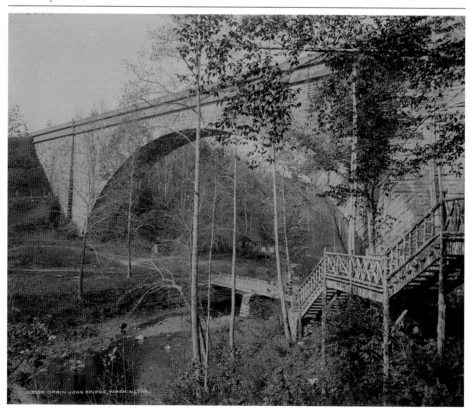

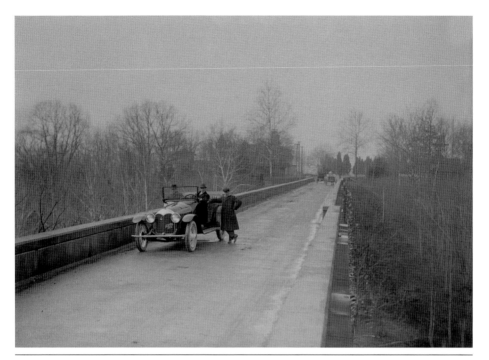

A motorist in 1915 crosses the Cabin John Bridge. Originally known as Conduit Road—for the water supply line that runs beneath—the road was later named MacArthur Boulevard, for the World War II hero. The bridge crossing remains a single lane today, with stoplights at either end regulating the flow of traffic.

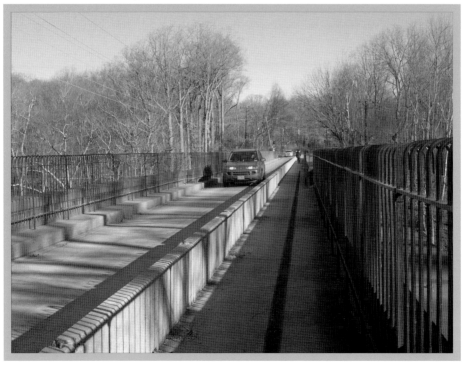

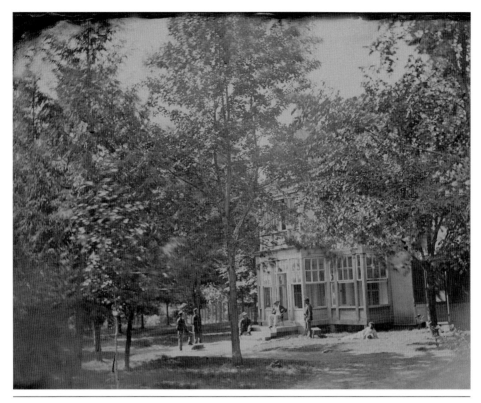

In 1842, Francis Preston Blair, a politically connected Washingtonian, built this spacious summerhouse off Georgia Avenue, just over the district line. He named the property "Silver Spring," for a shimmering spring running through the property. During the Civil War, Confederate forces commandeered the house as a headquarters during the Battle of Fort Stevens. Here, Union soldiers inspect the mansion after the Confederates' retreat. The house was razed in the 1950s to make way for apartment buildings.

Construction of an extensive line of fortifications ringing the district had begun in 1861, at the outbreak of the Civil War, built to protect the city from Confederate attack. At the westernmost boundary of the line was Fort Sumner, just across the district line in Montgomery County, protecting the reservoir of Washington's water system, the C&O Canal, and the shoreline of the Potomac. The site, off Sangamore Road, is today covered by subdivisions.

www.arcadiapublishing.com

Discover books about the town where you grew up, the cities where your friends and families live, the town where your parents met, or even that retirement spot you've been dreaming about. Our Web site provides history lovers with exclusive deals, advanced notification about new titles, e-mail alerts of author events, and much more.

Find Your Place in History.